I ♥ Hearts

I Love Hearts

A Coloring Book for All

By Kimberly Garvey

Color these and keep them for yourself or give them away to someone you love.

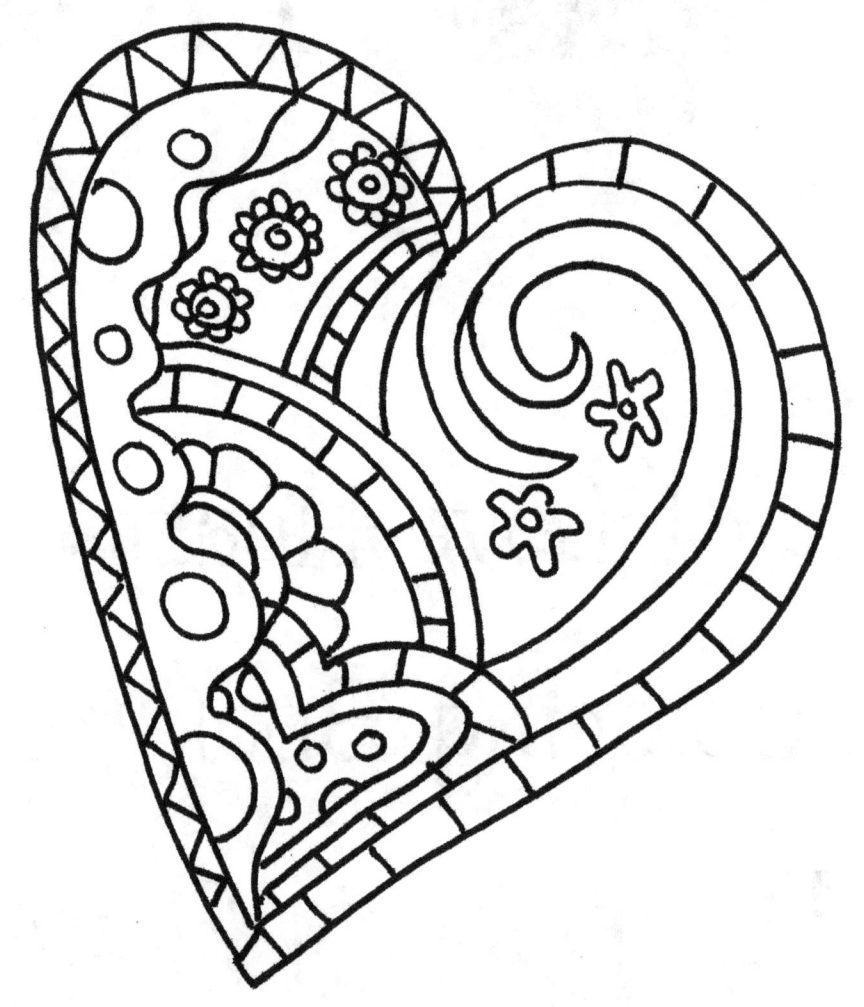

Copyright 2016 by Kimberly Garvey

All Rights Reserved.

No reproduction of any kind without consent.

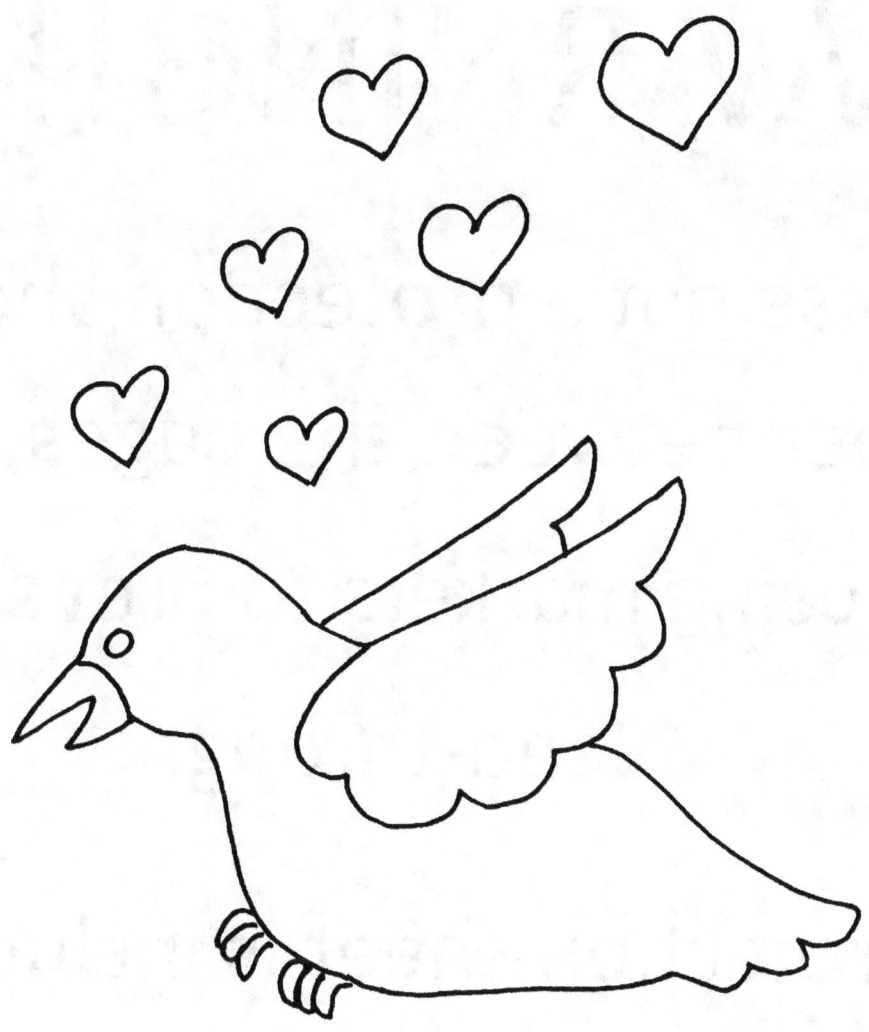

This book is dedicated to everyone I love.

WARNING!!!!

Please put a protection sheet of paper between the pages when using markers to prevent bleed-through.

A protection sheet is included at the back of this book.

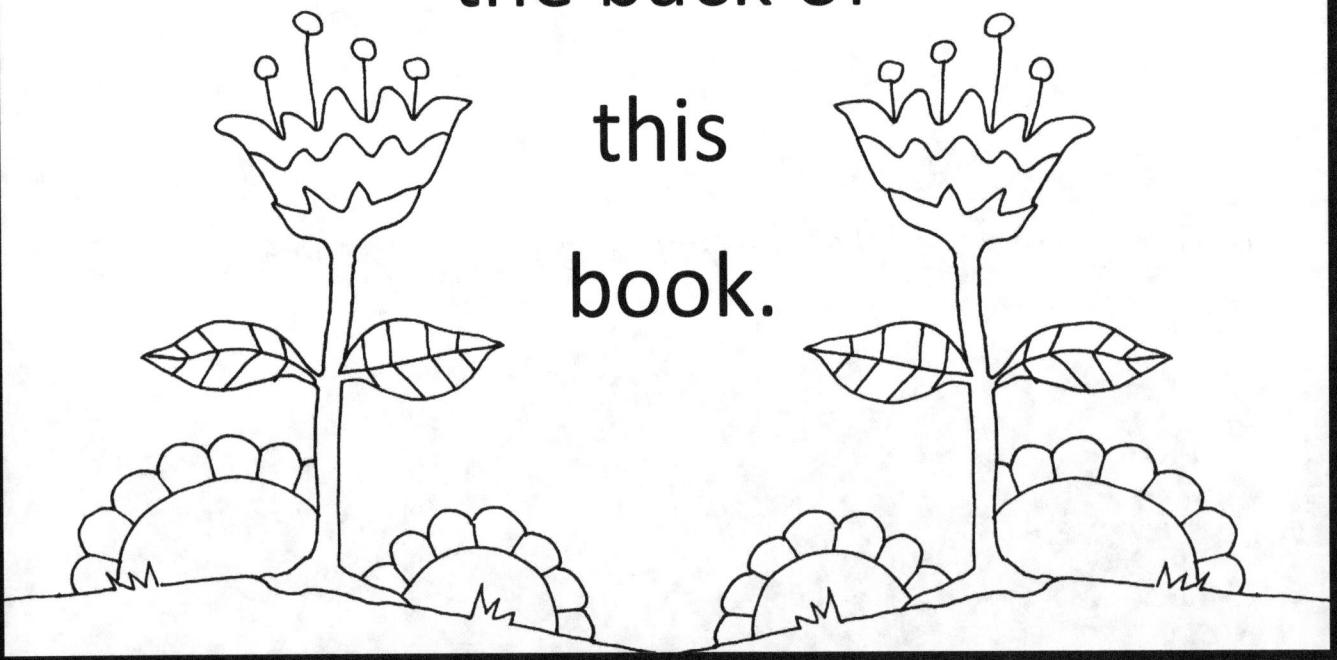

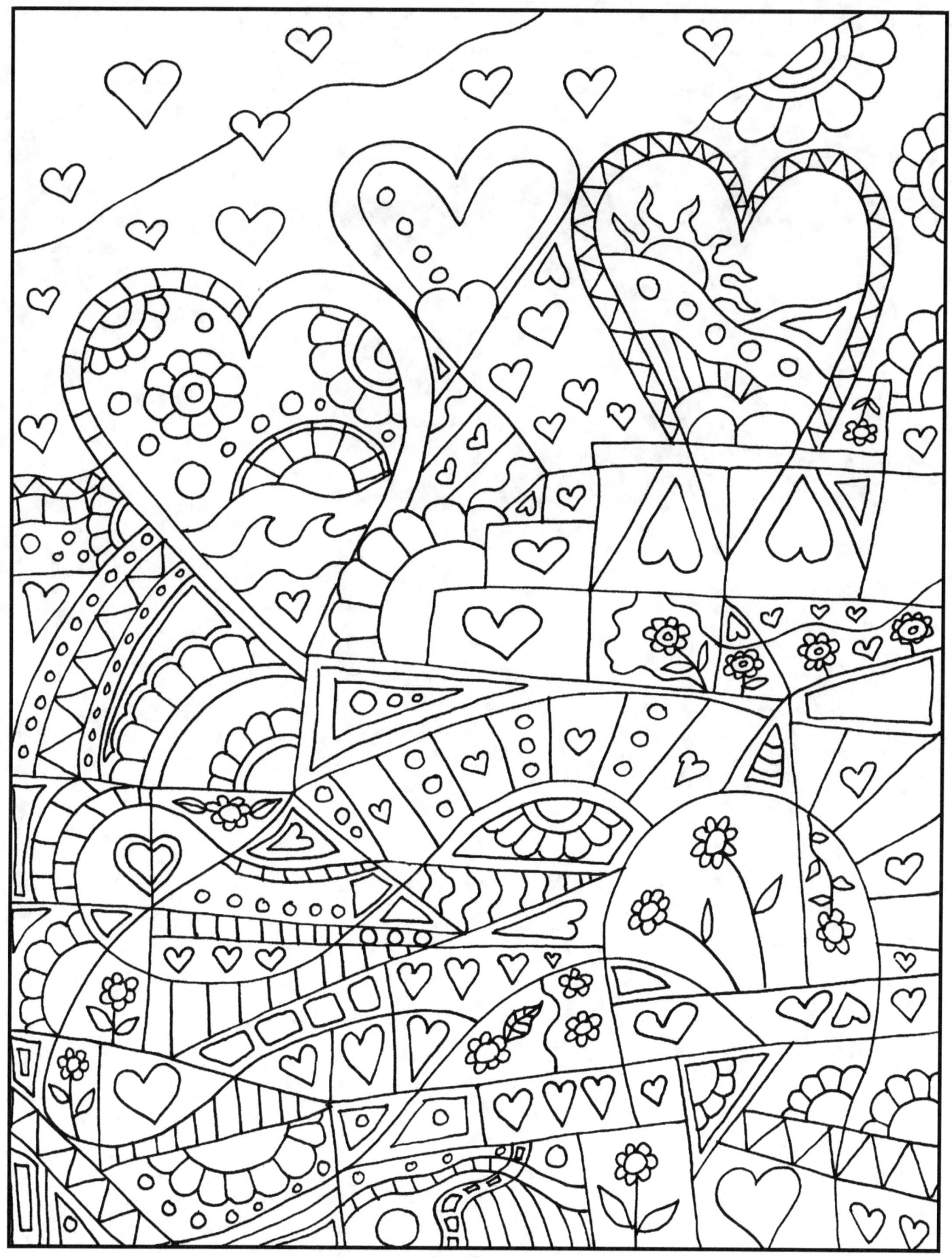

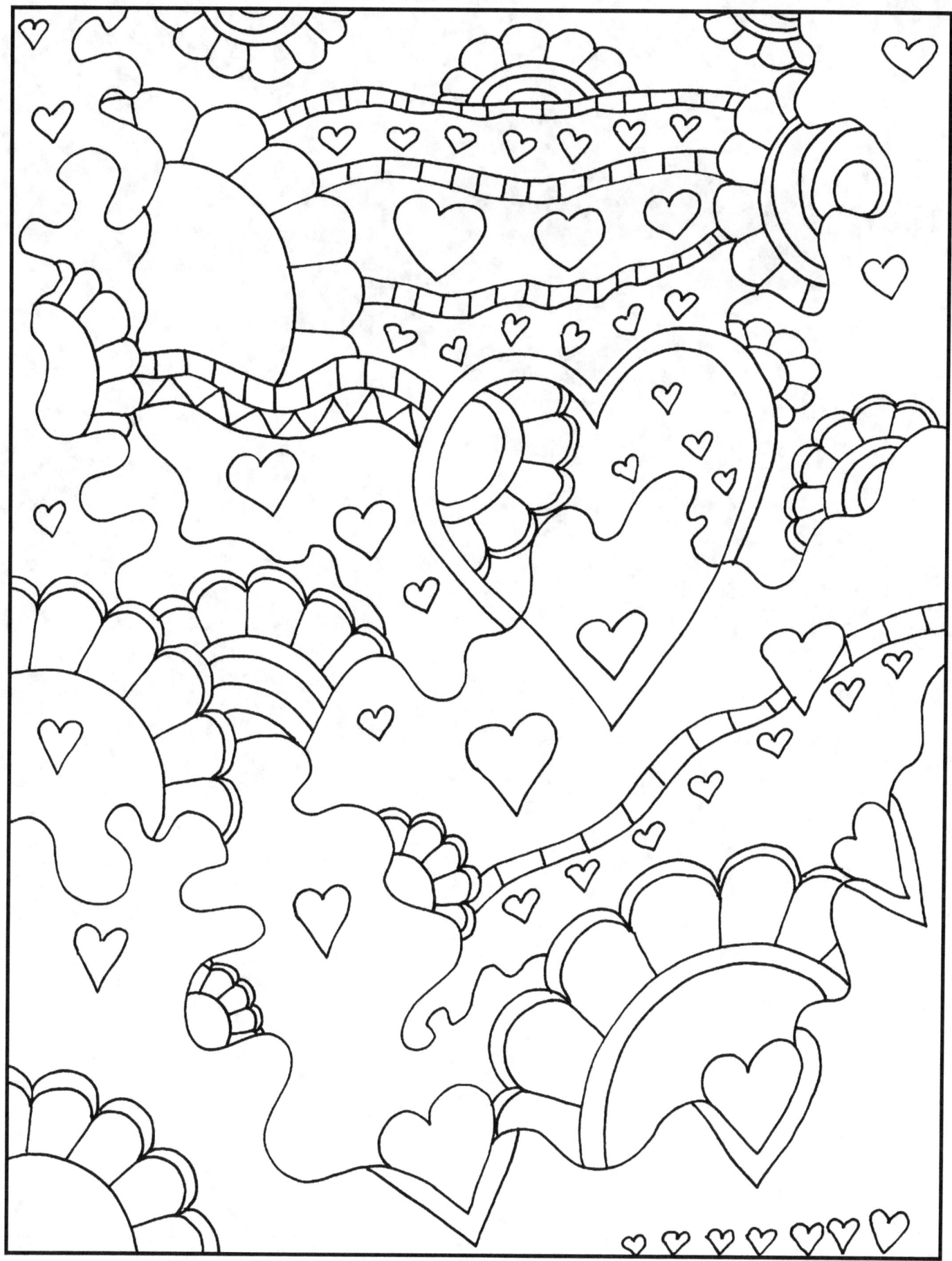

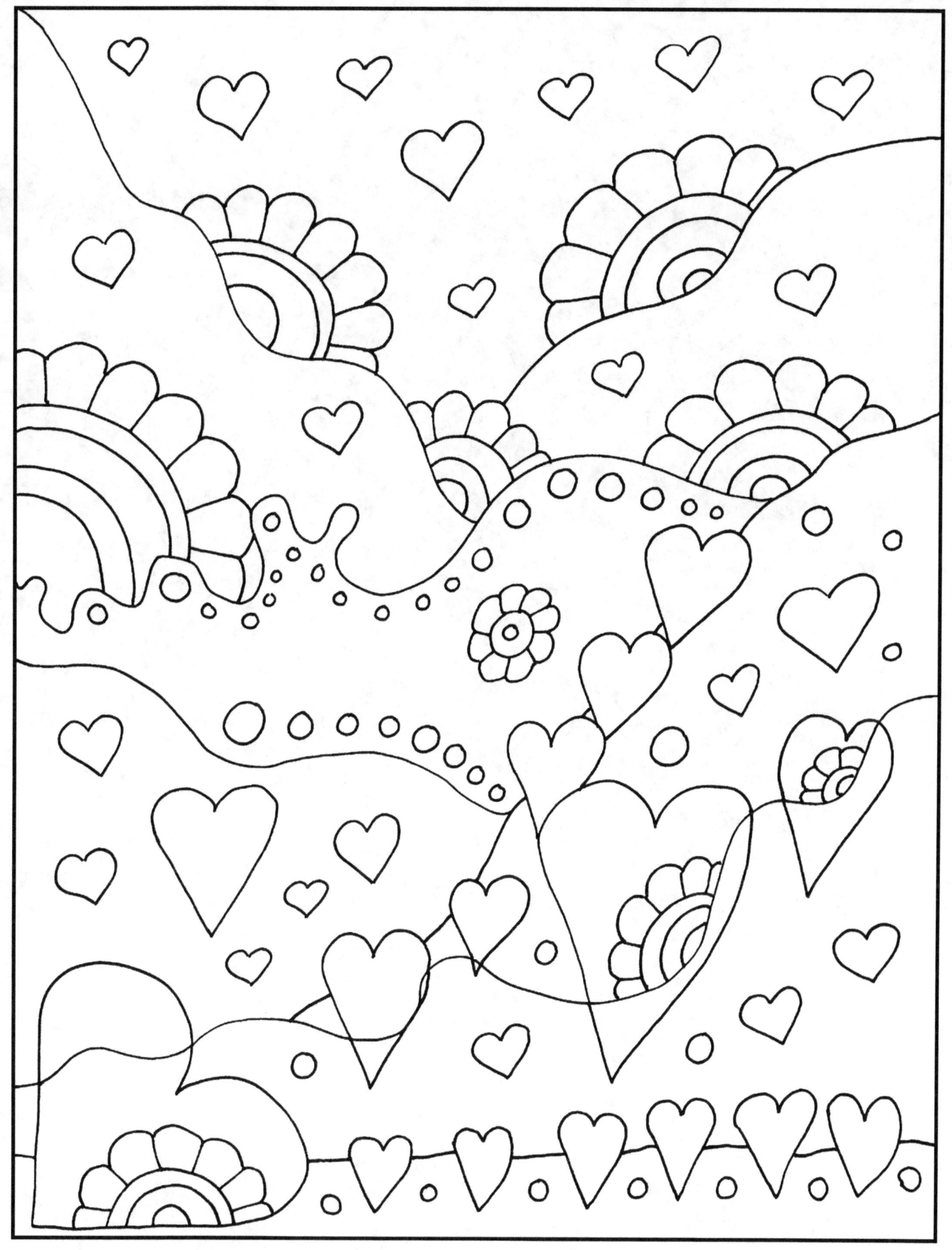

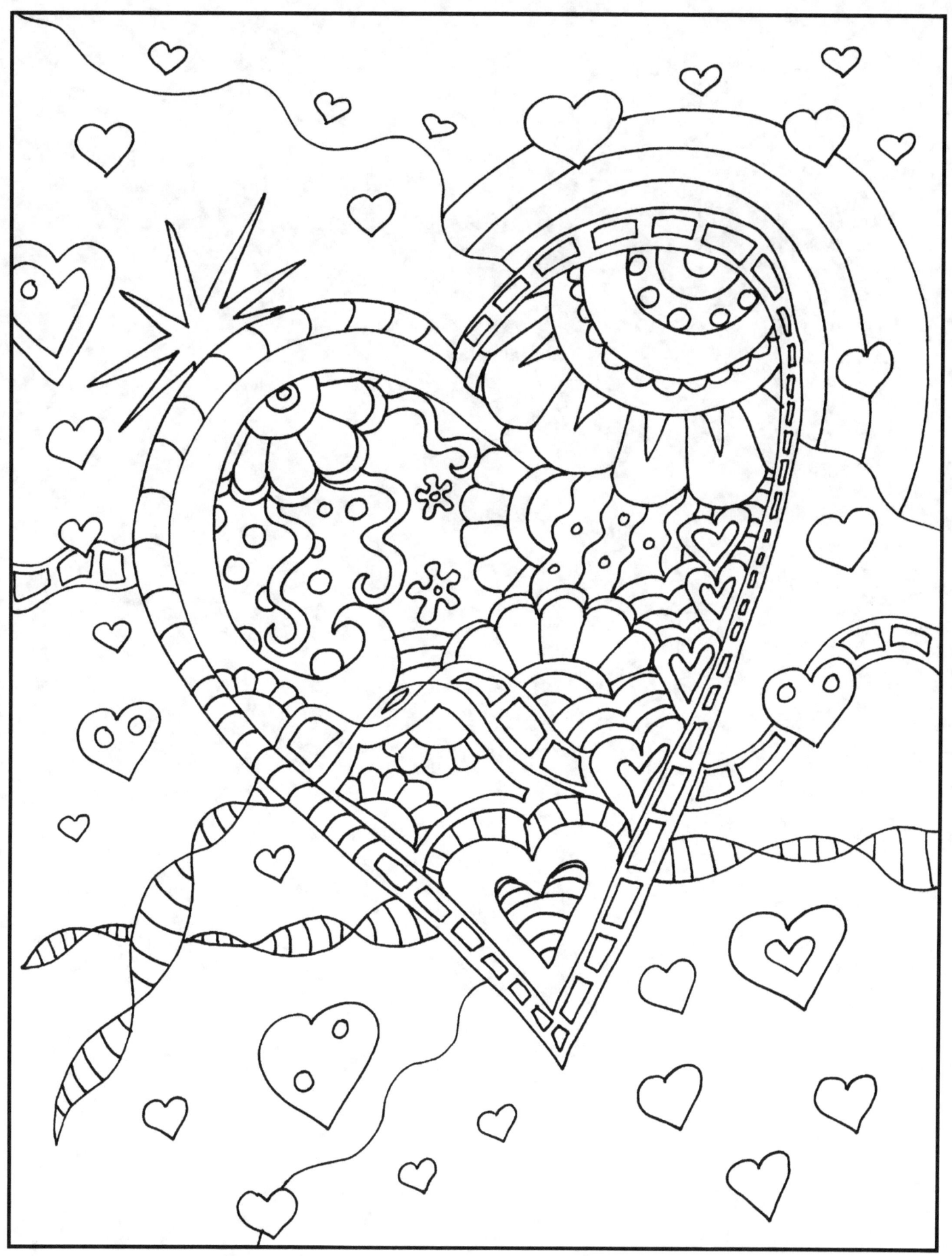

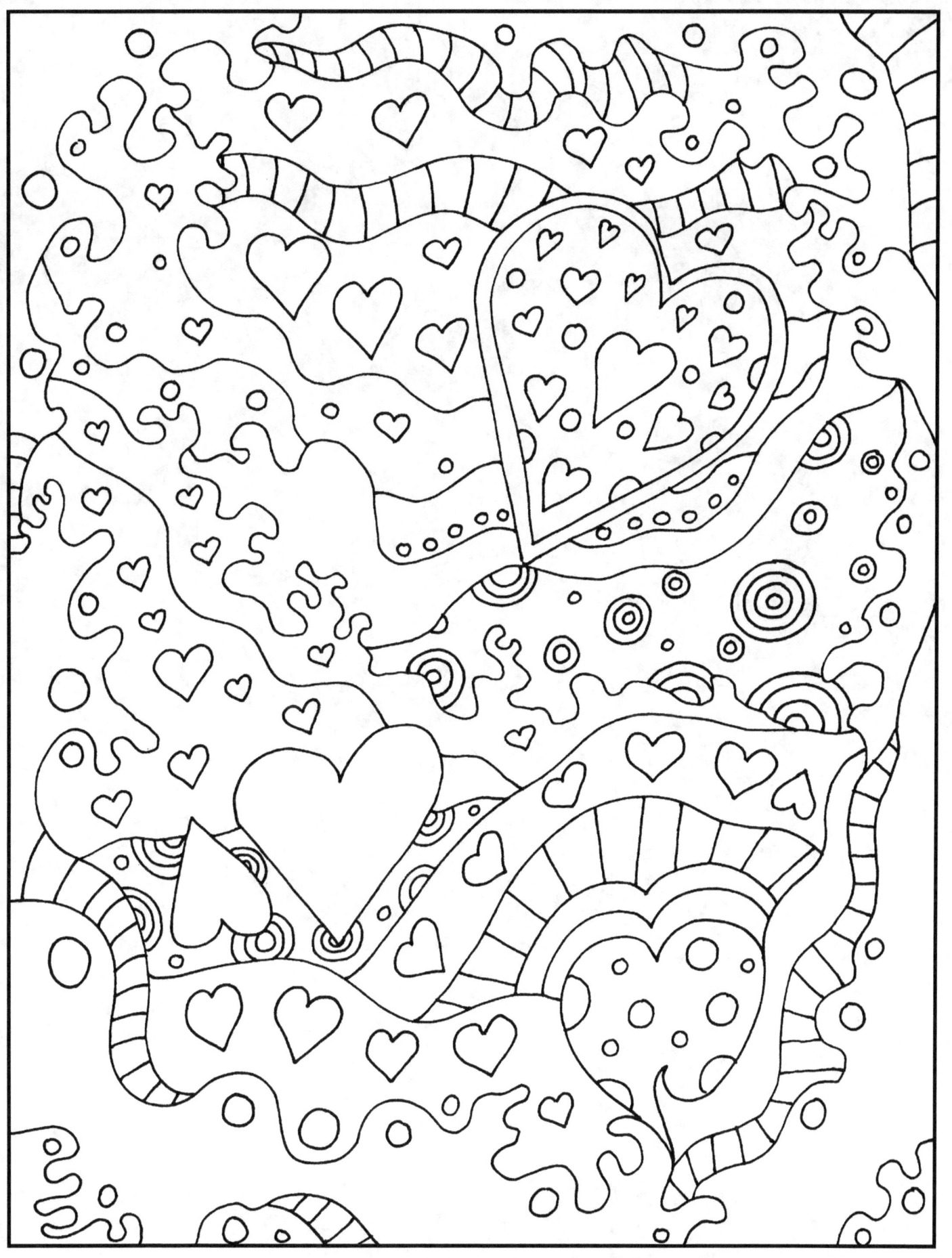

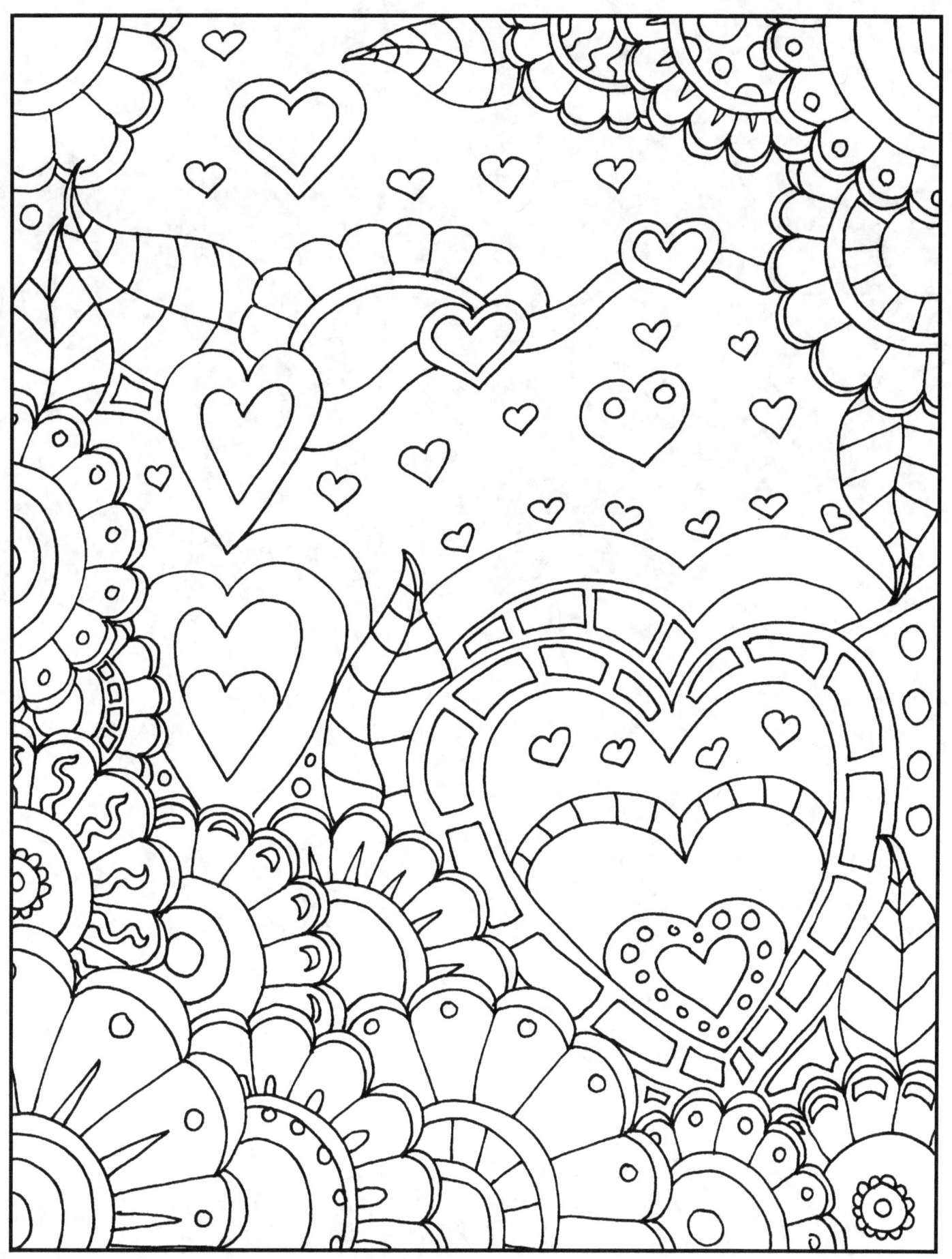

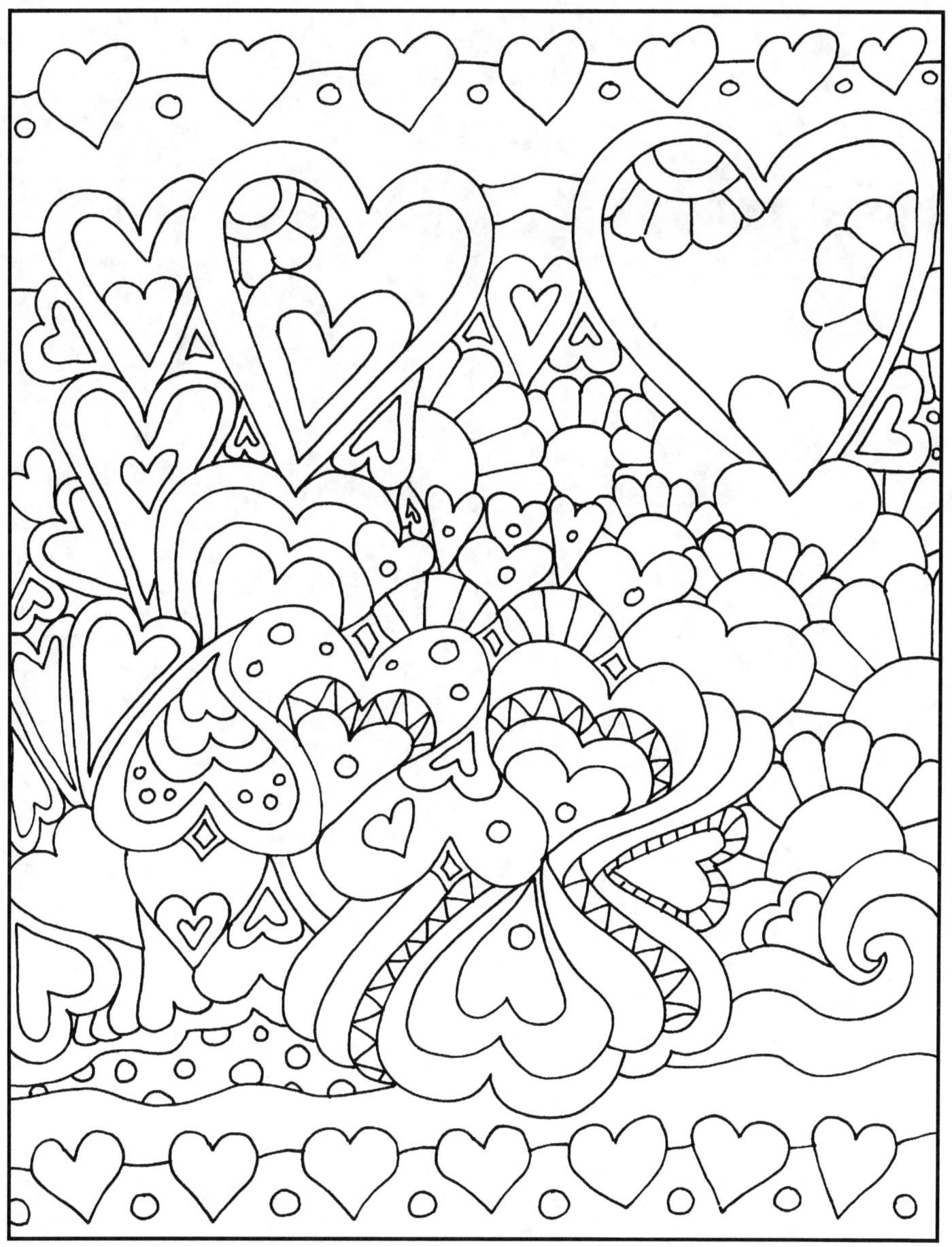

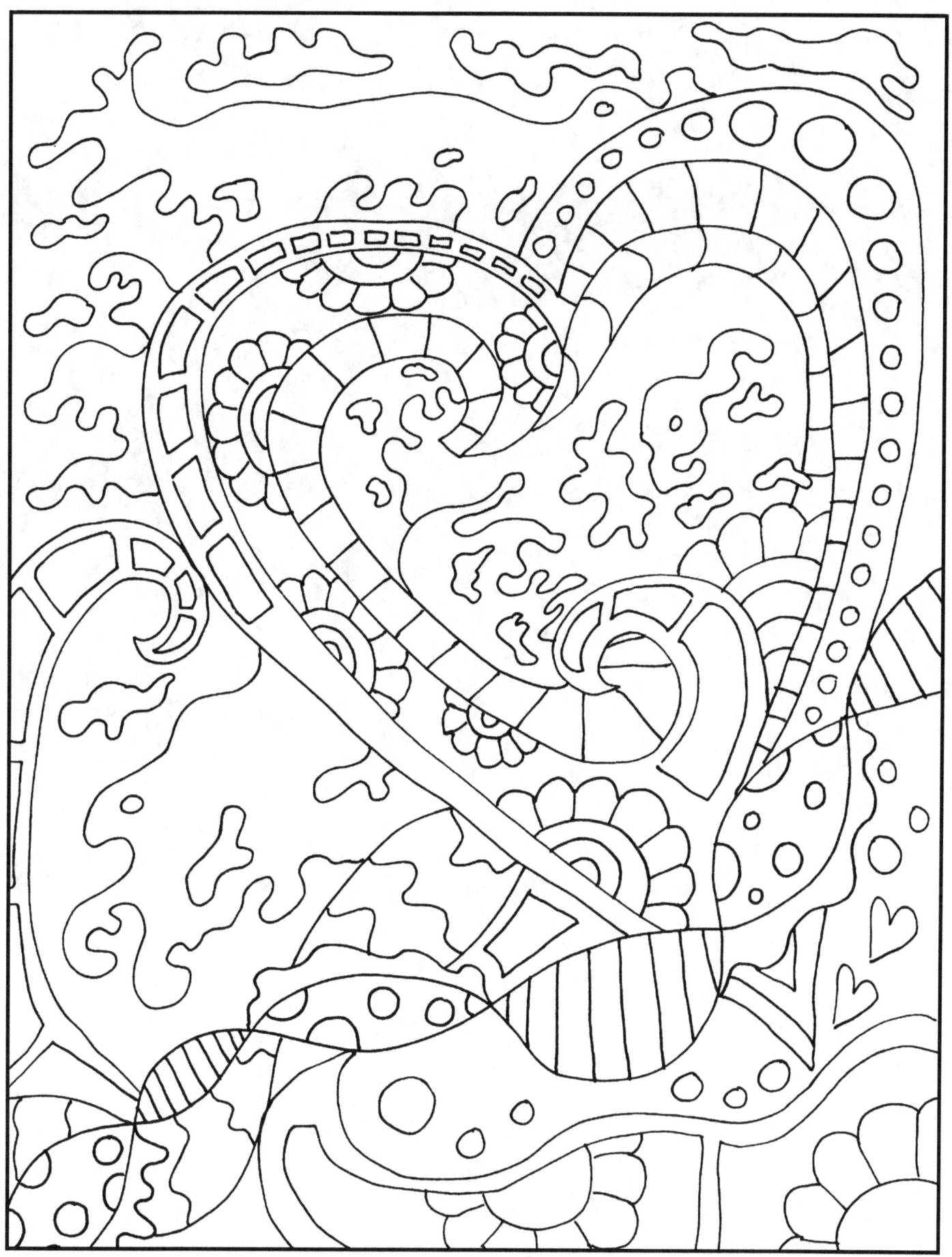

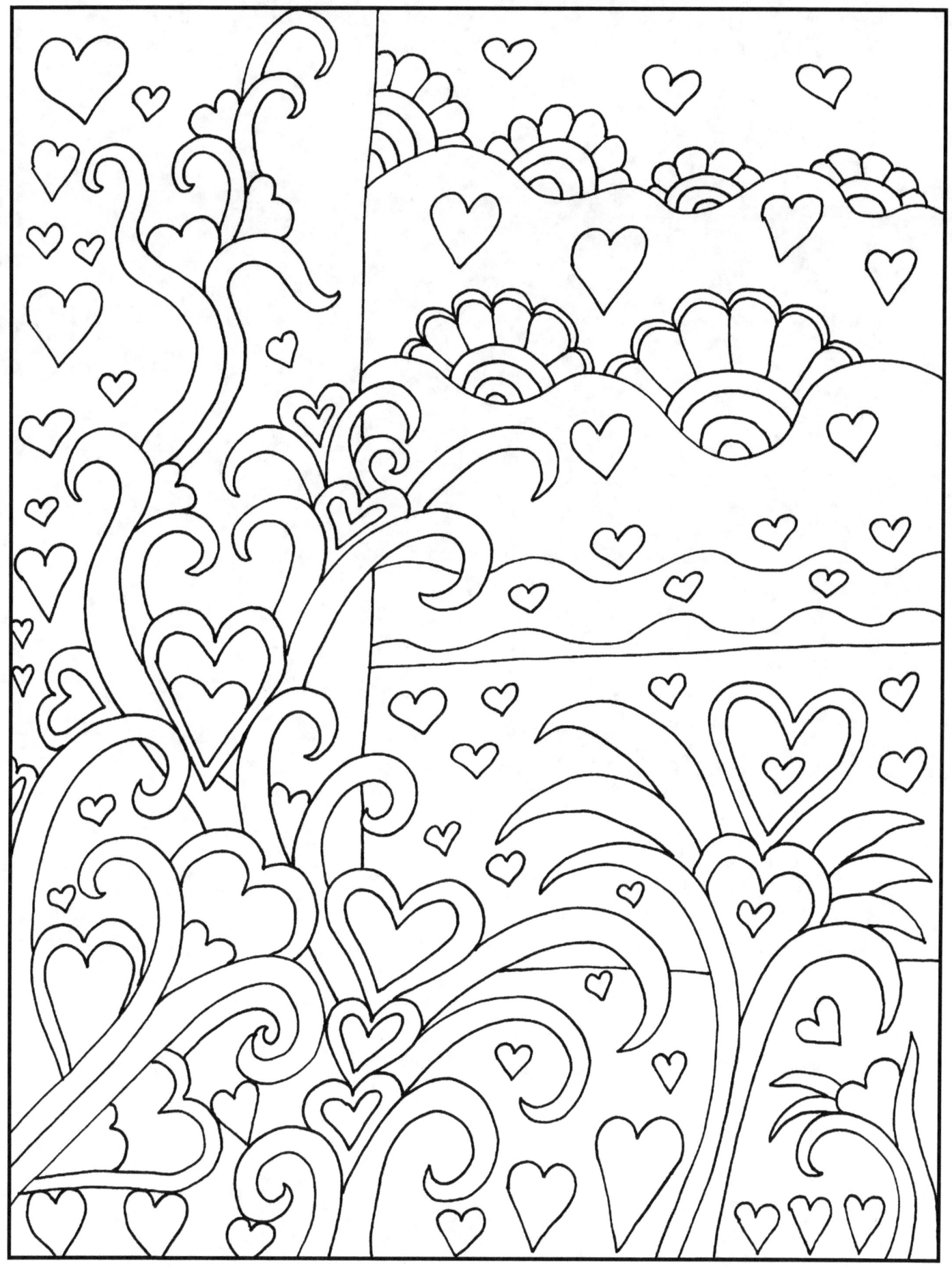

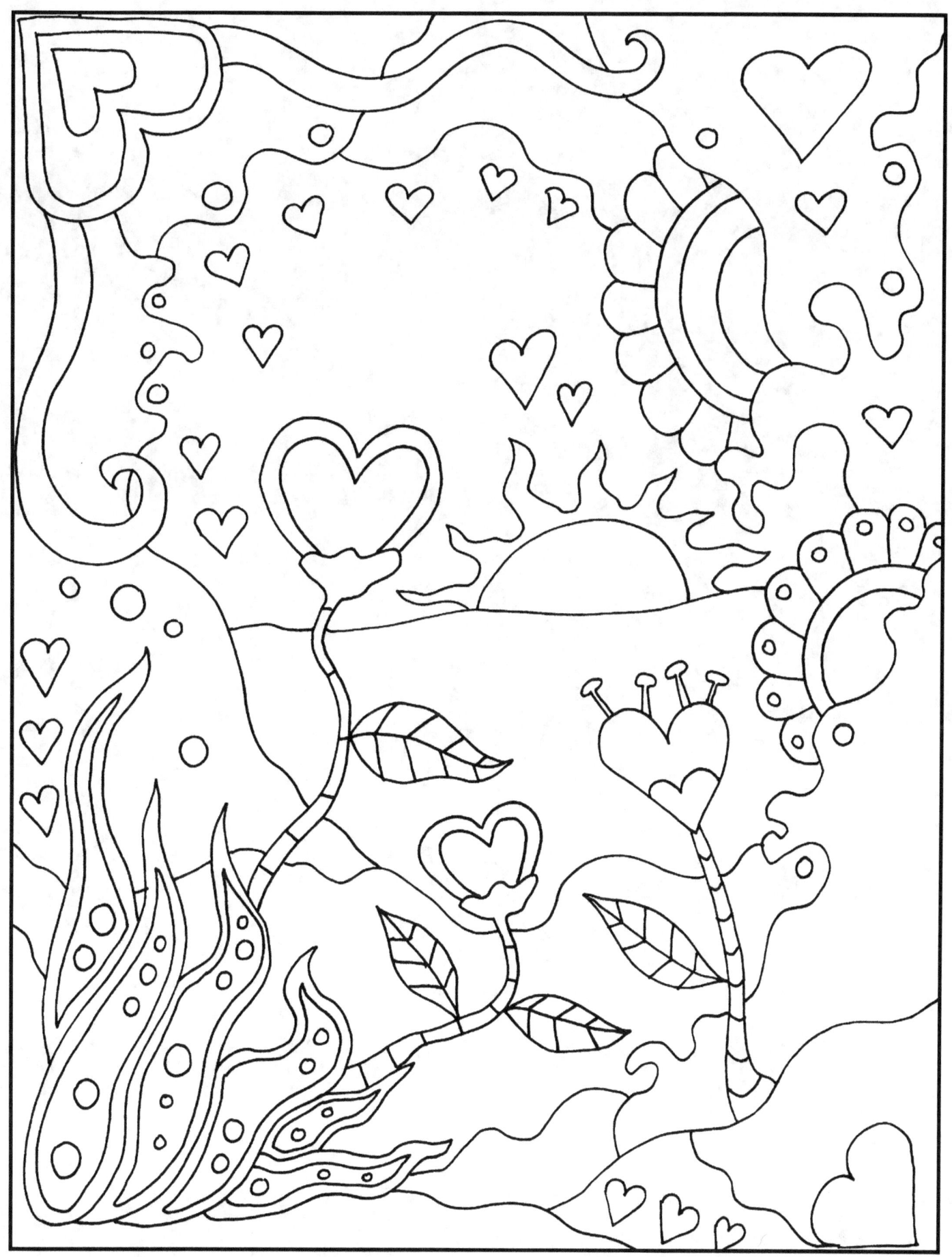

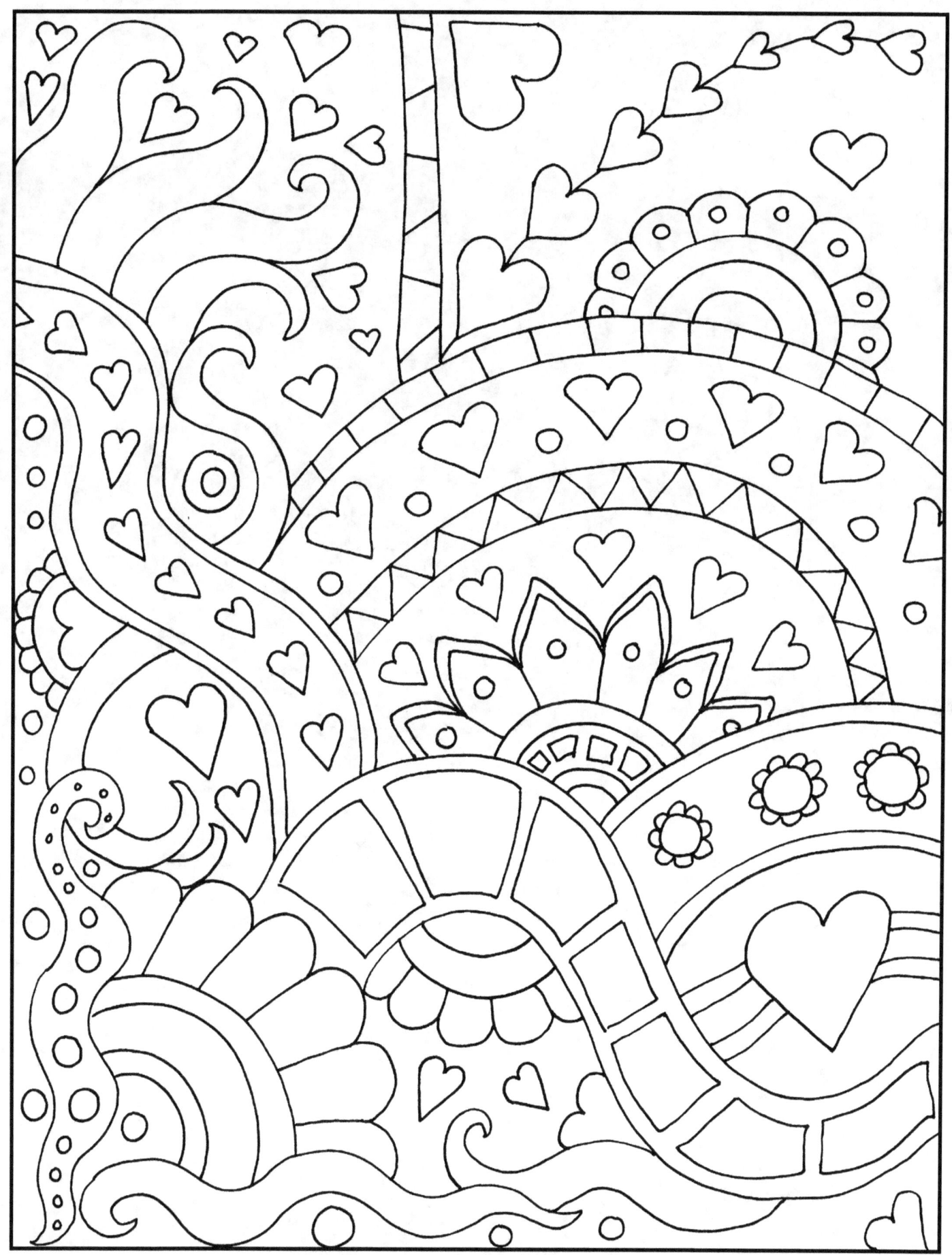

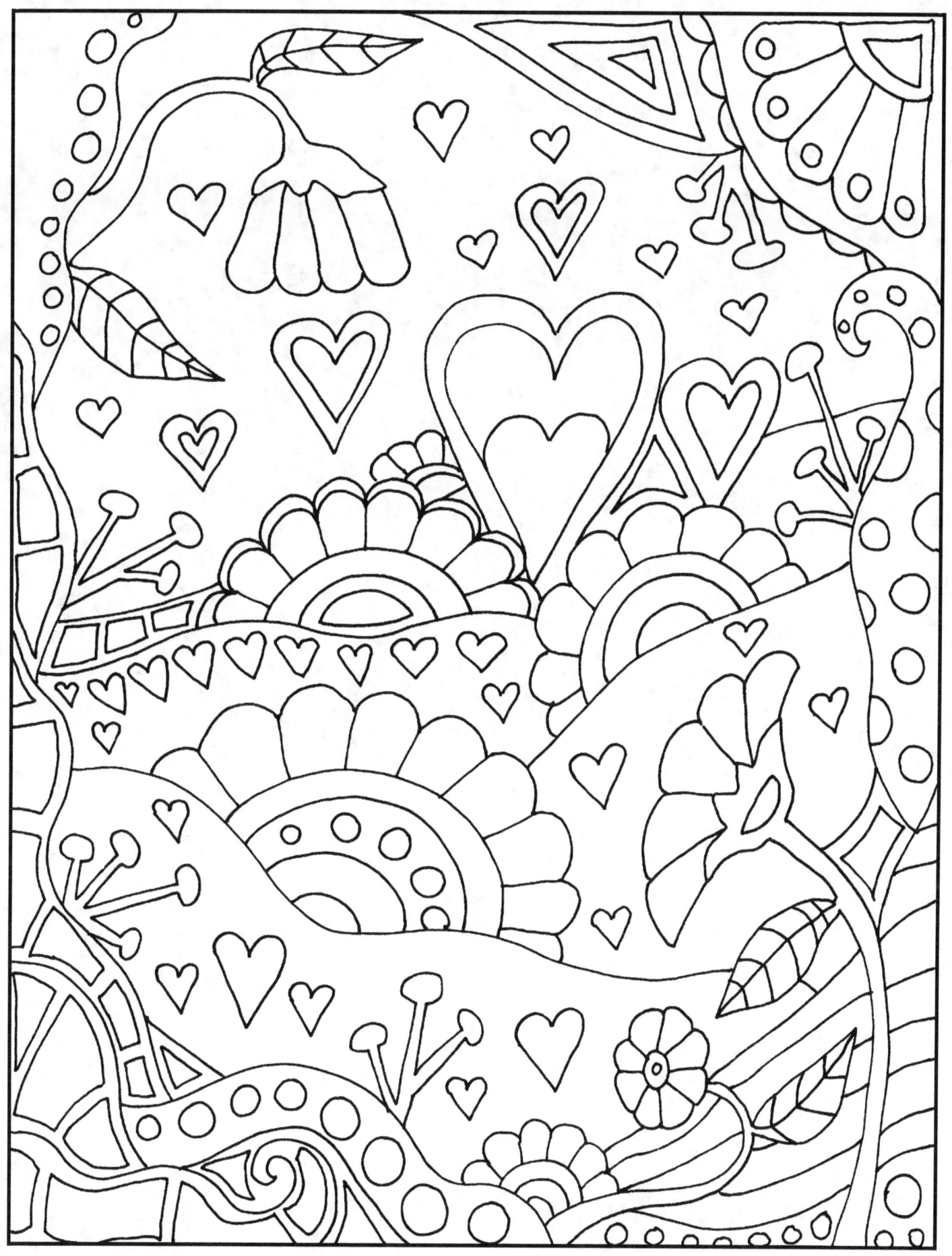

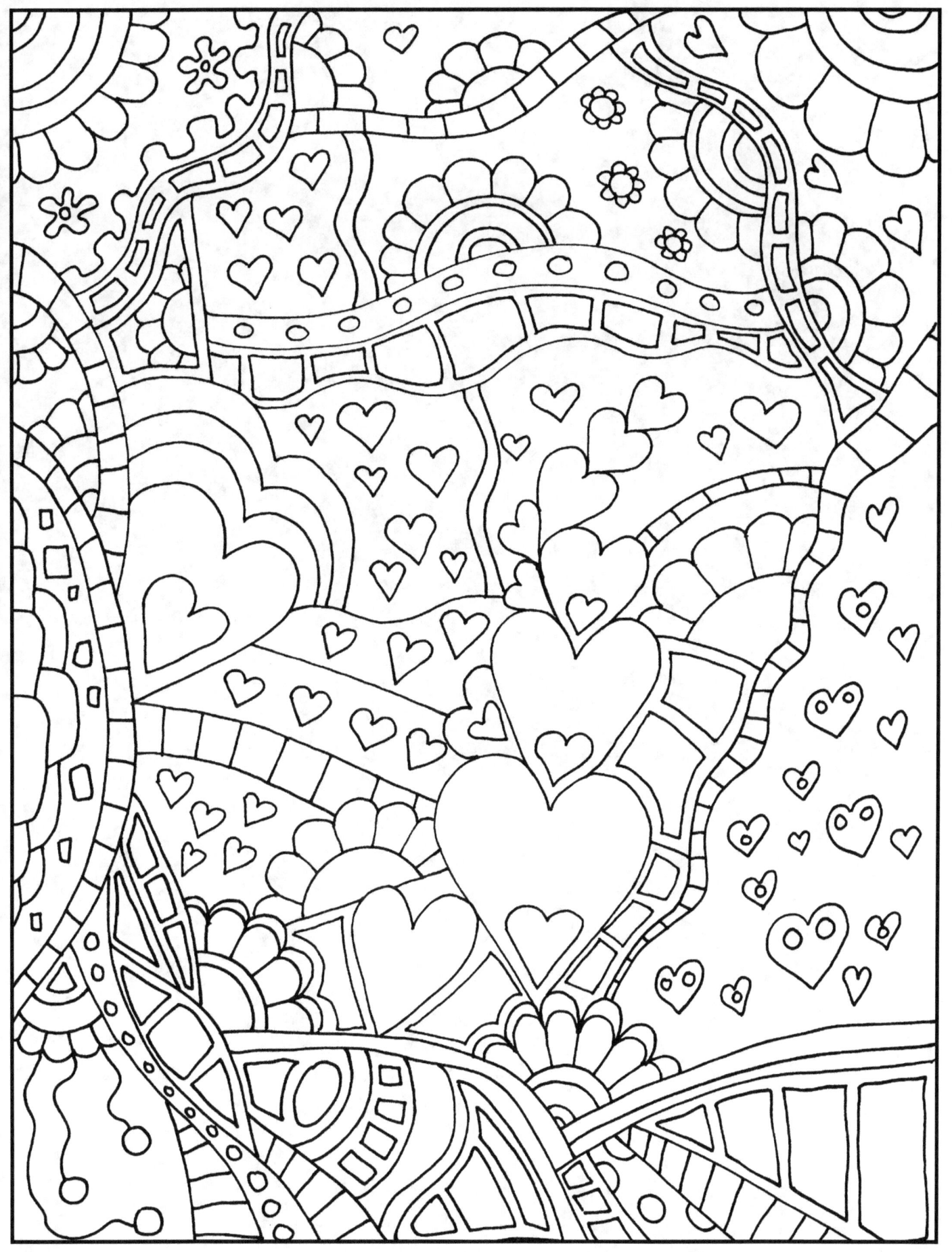

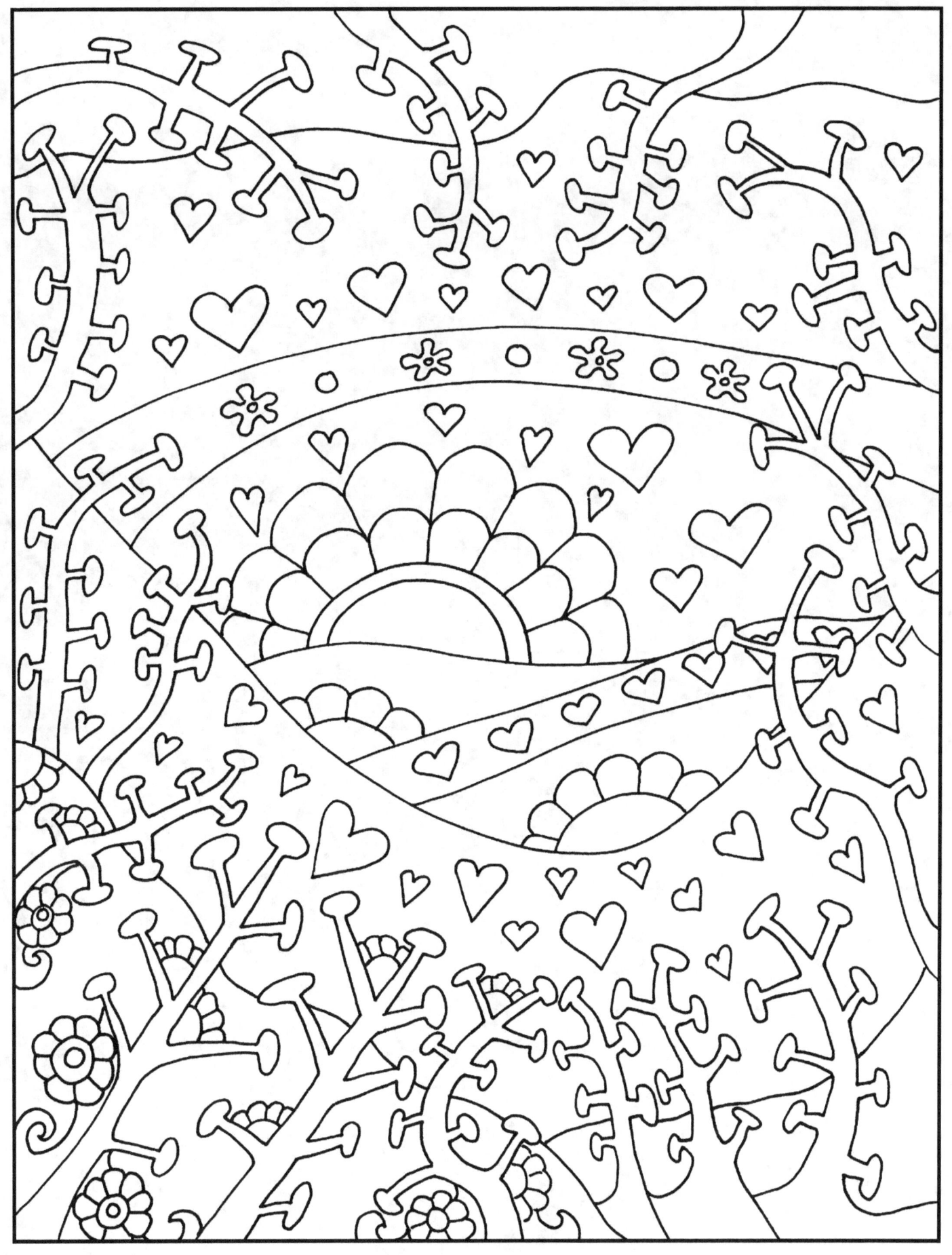

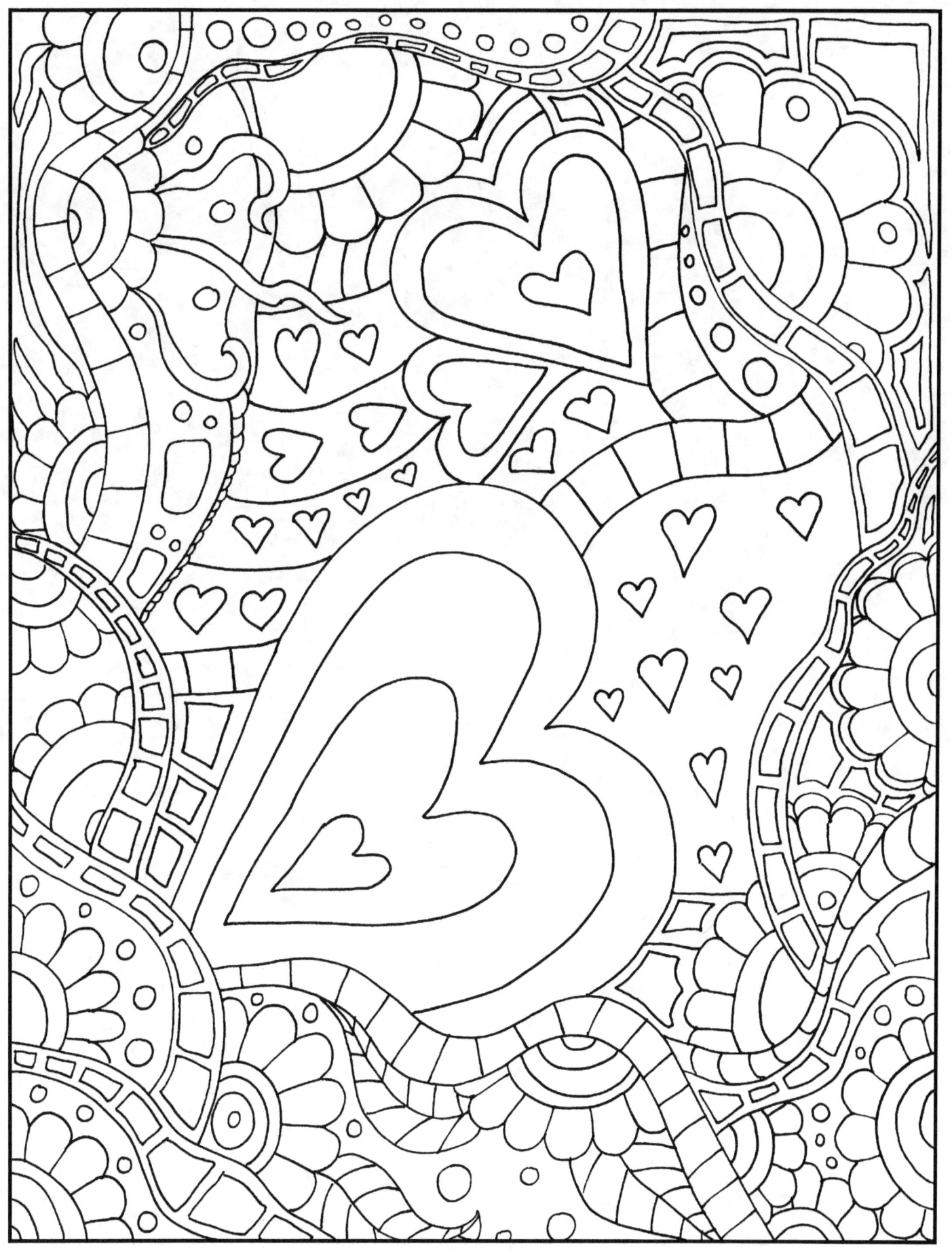

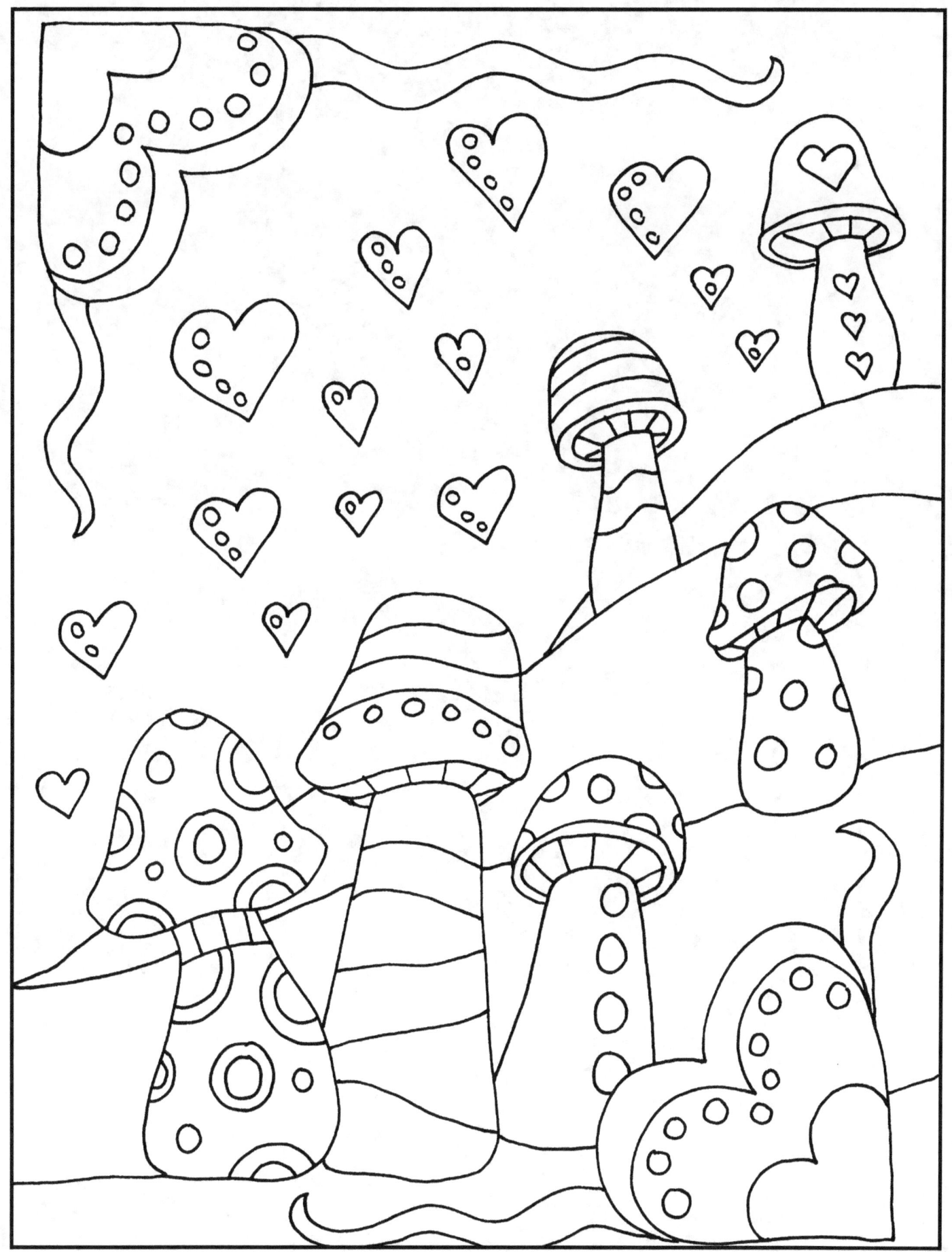

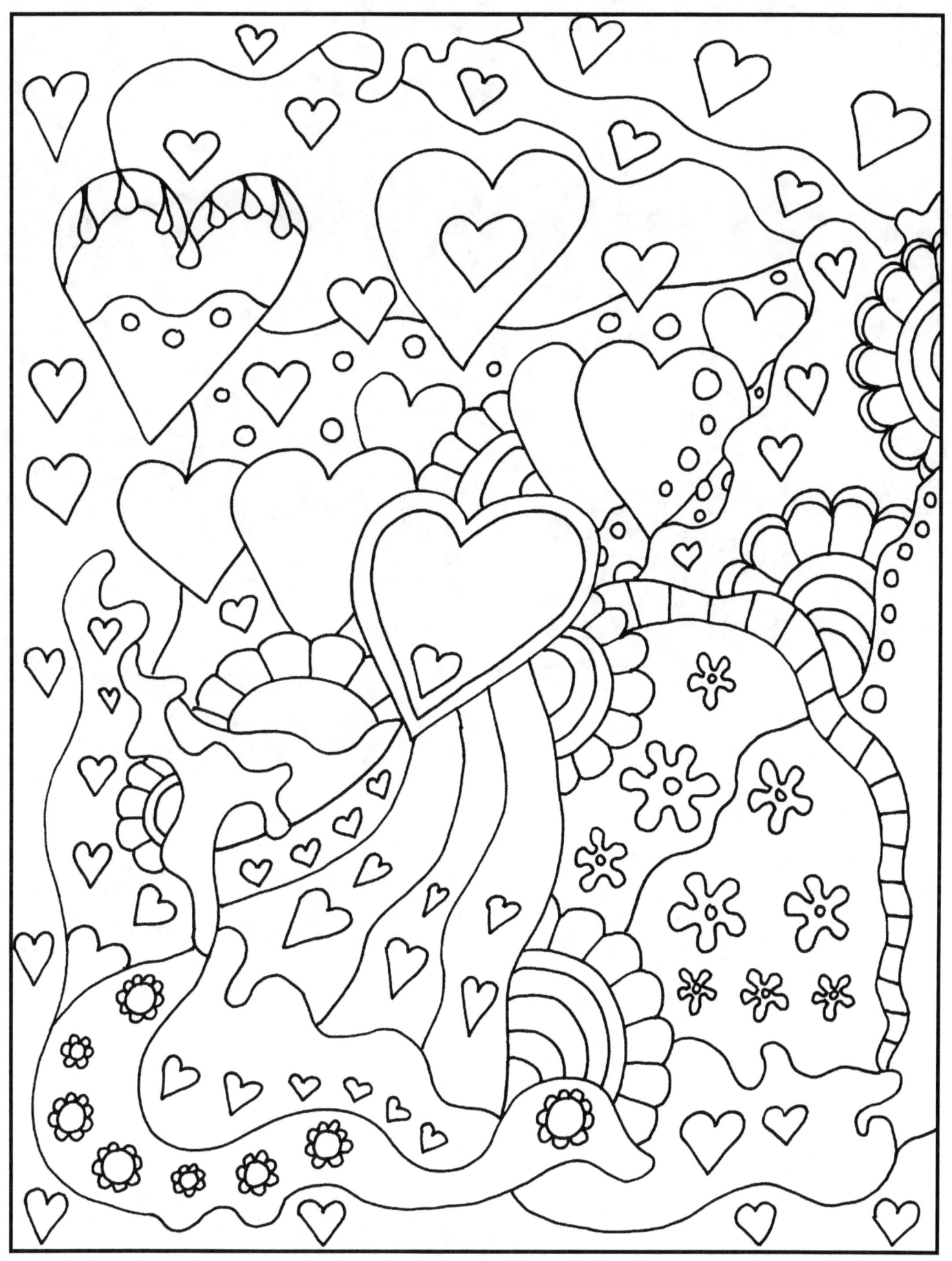

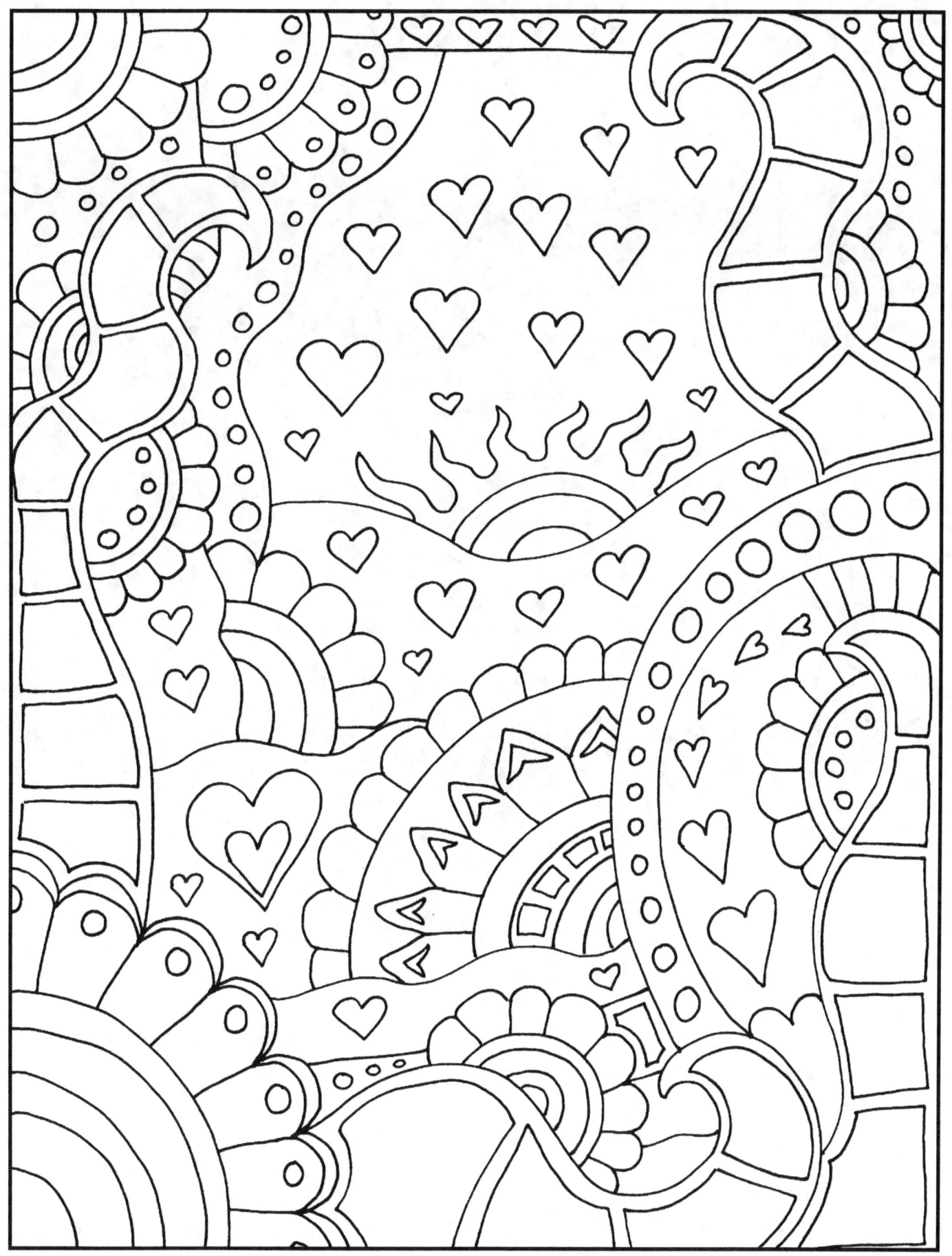

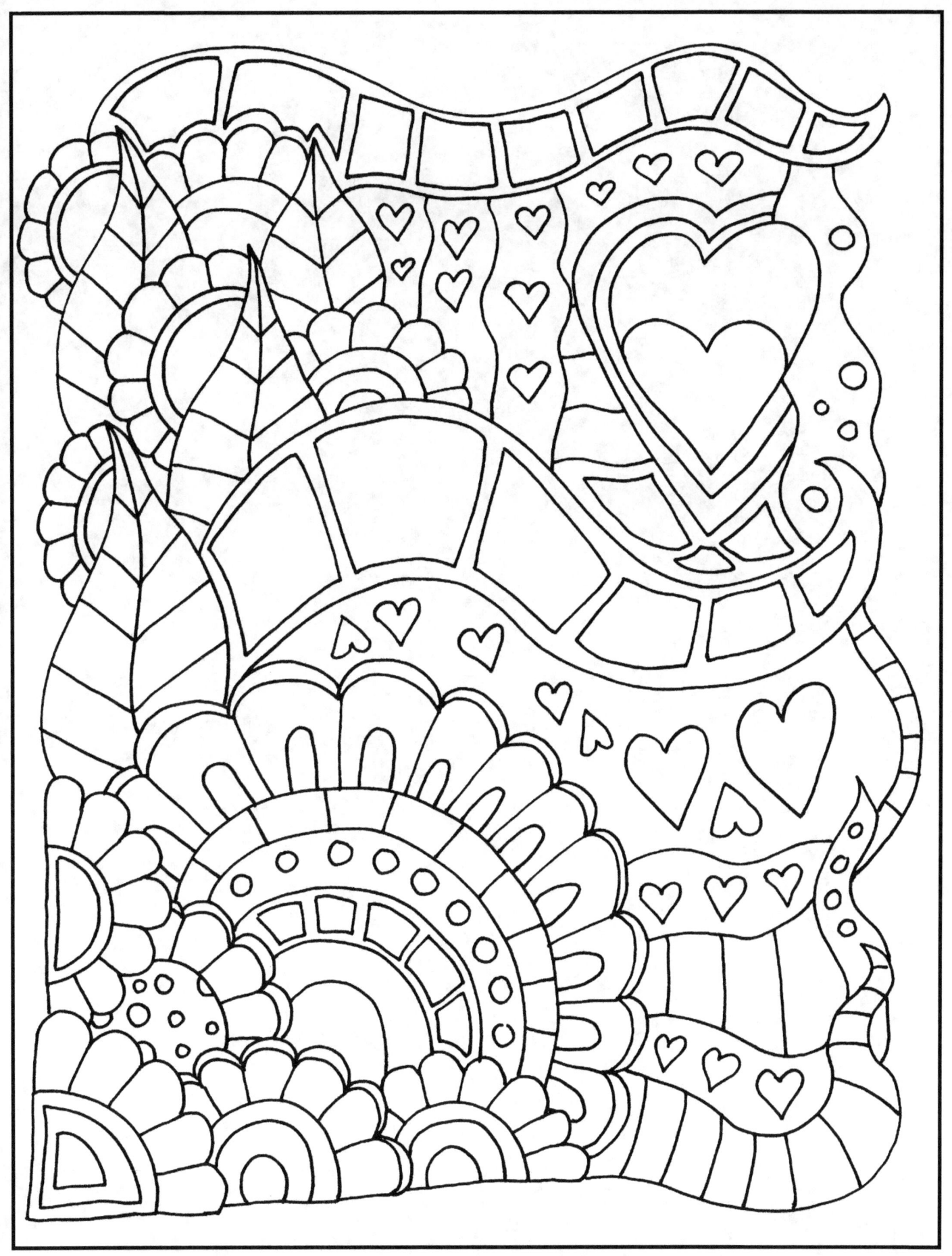

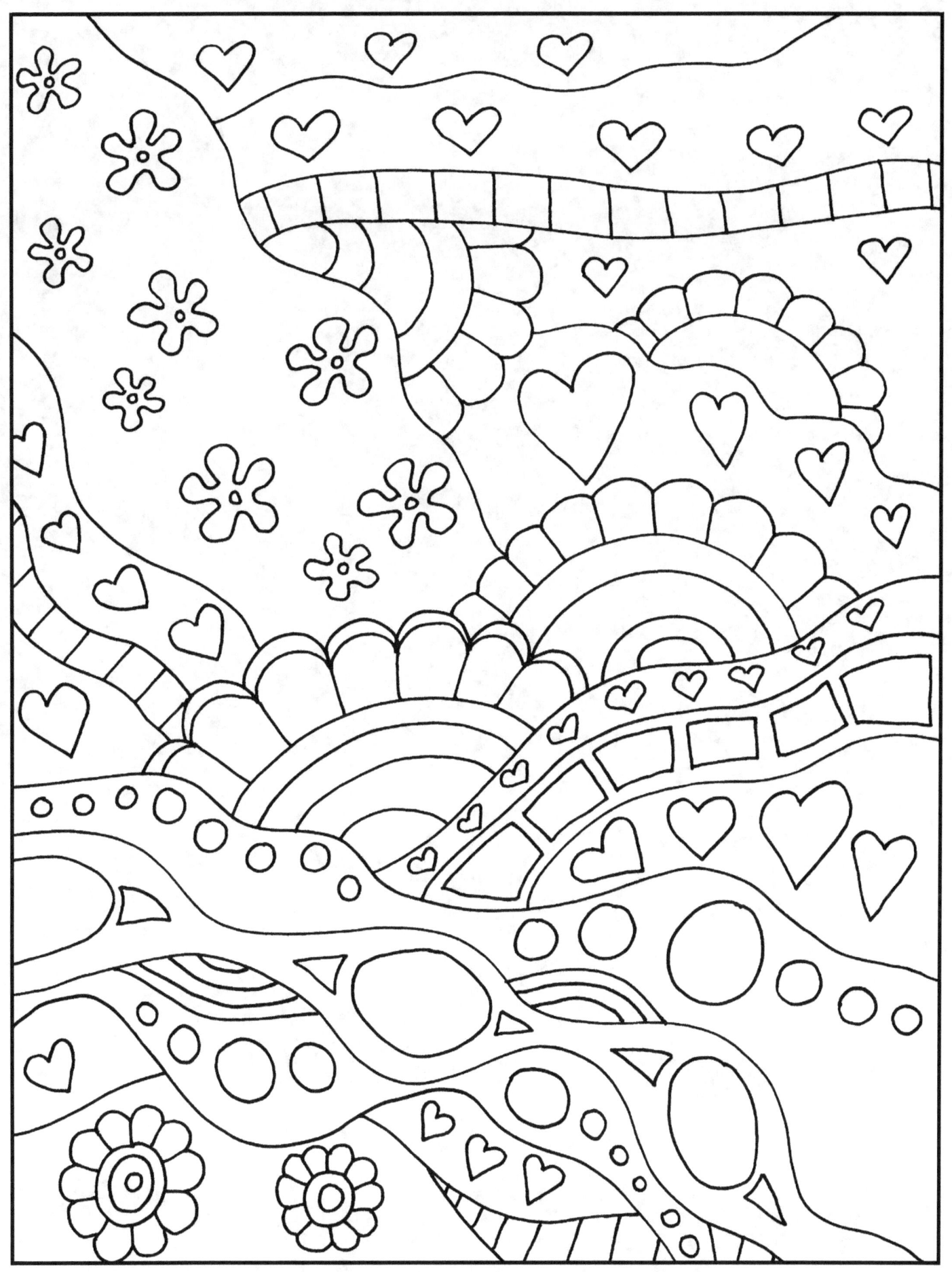

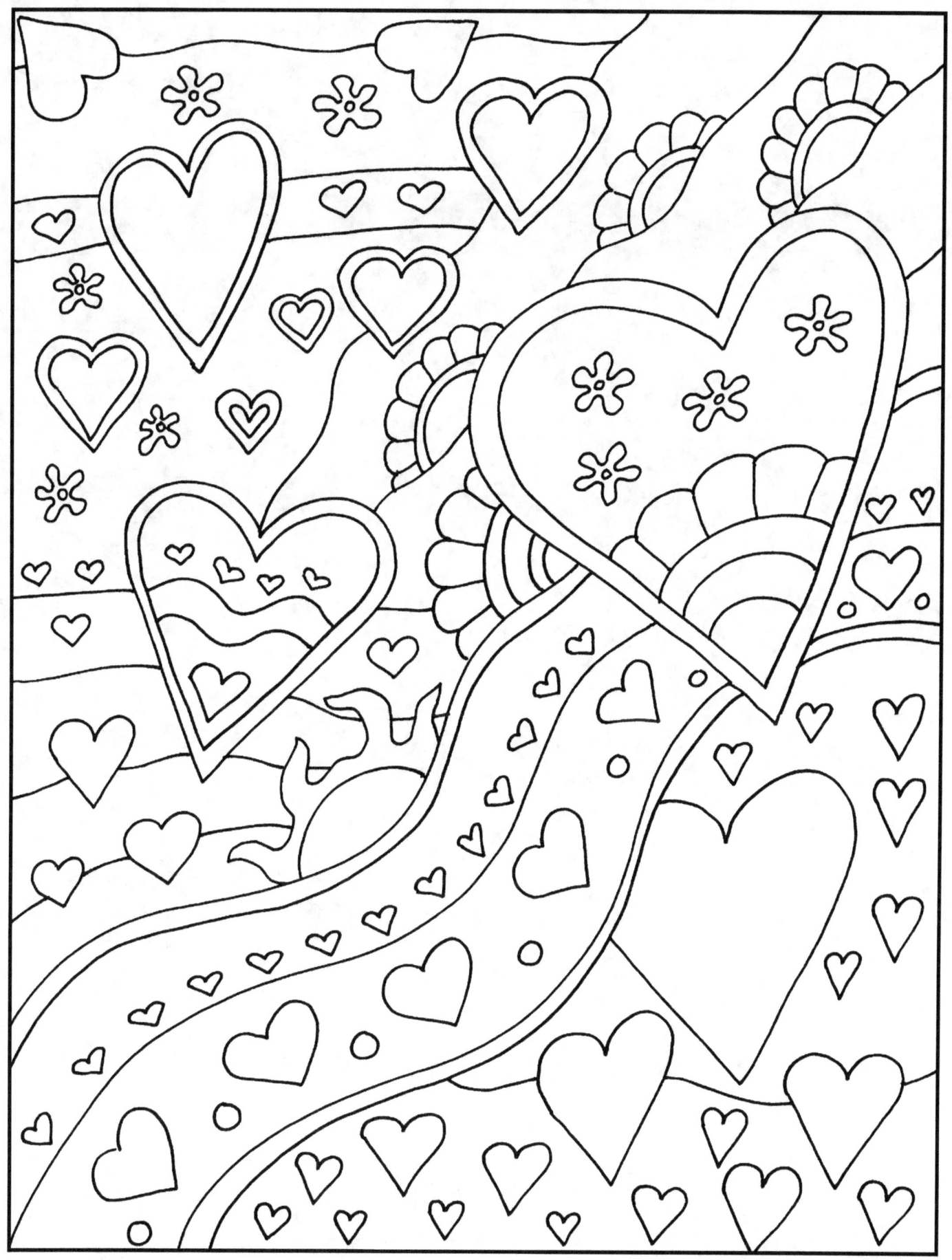

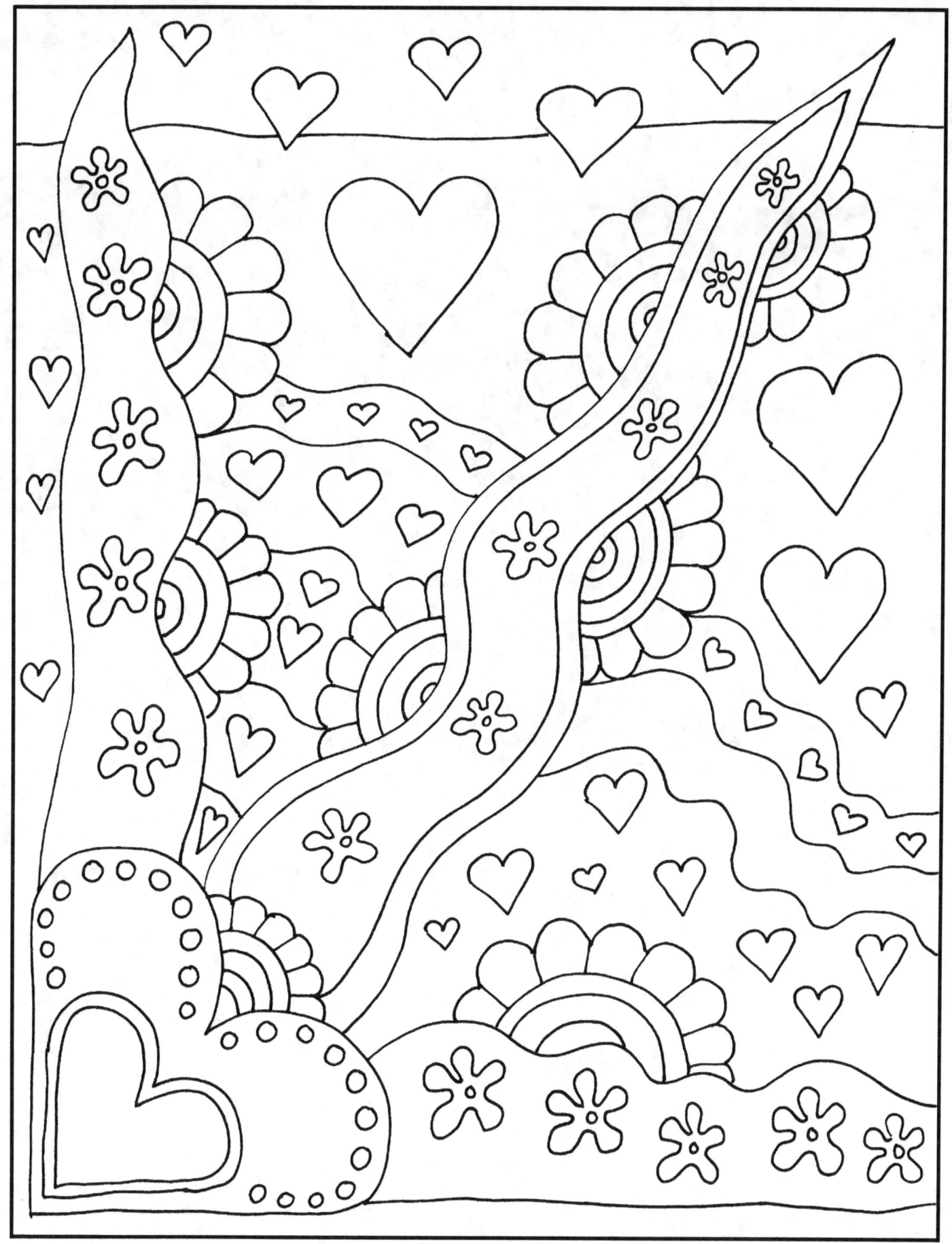

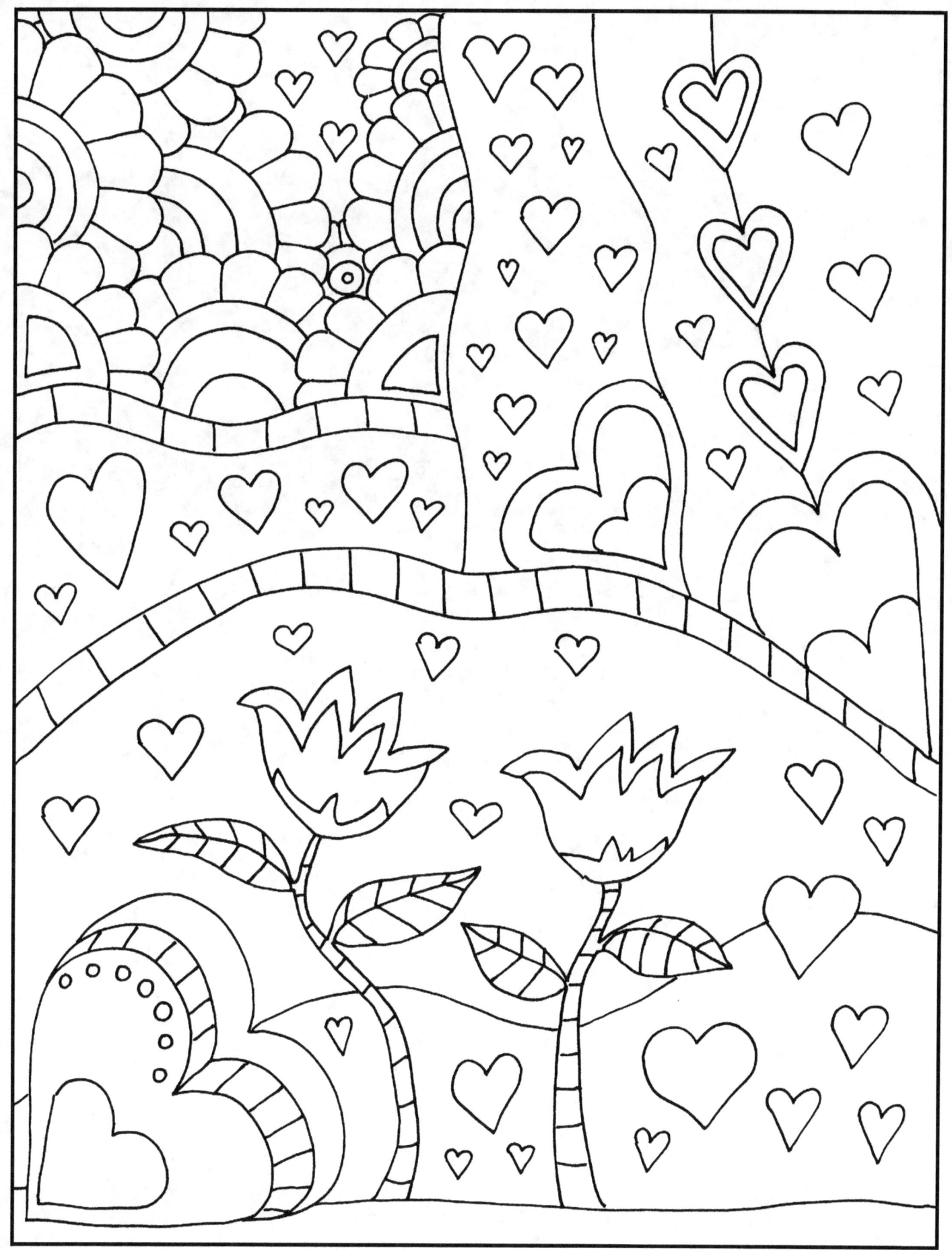

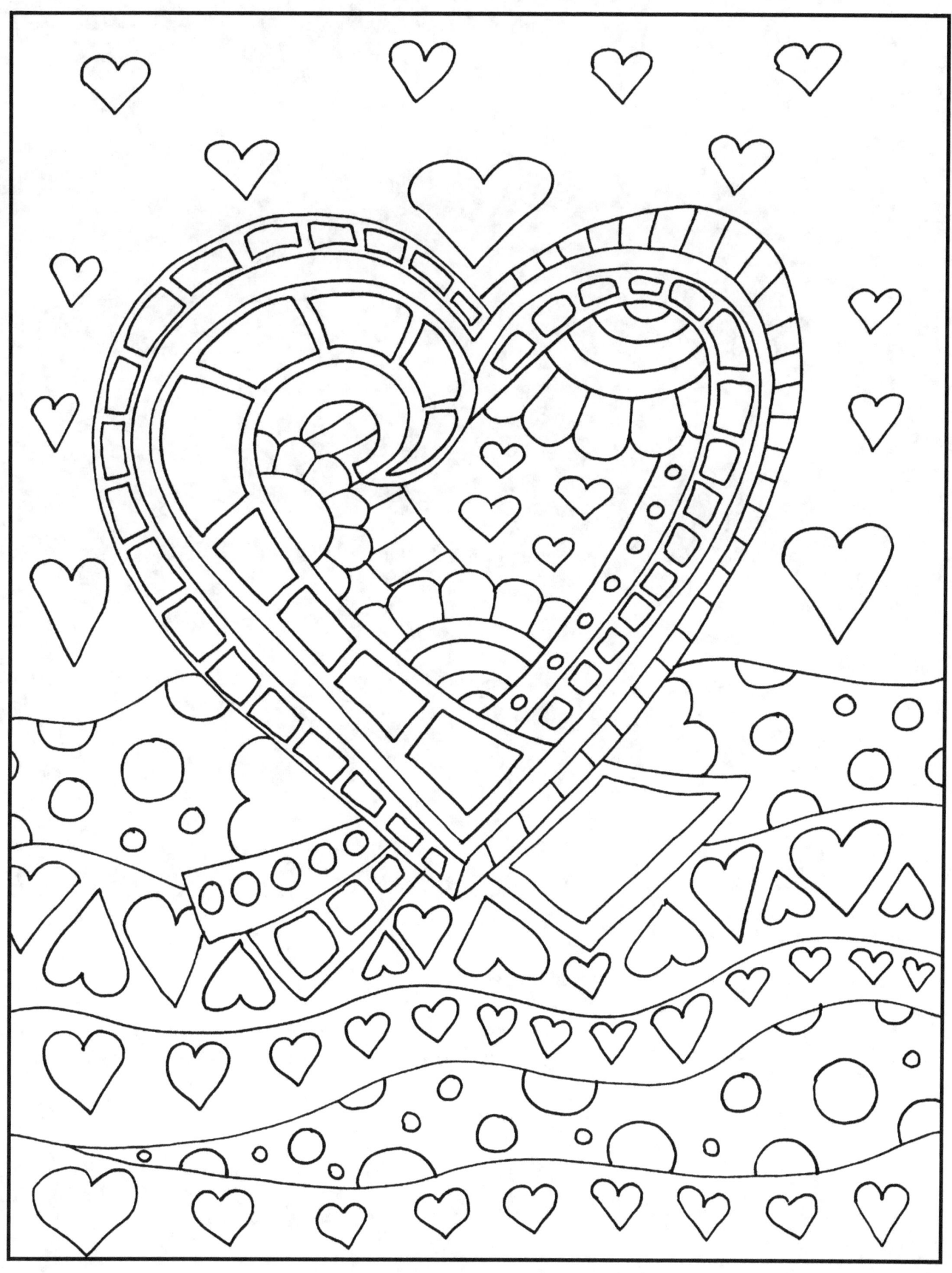

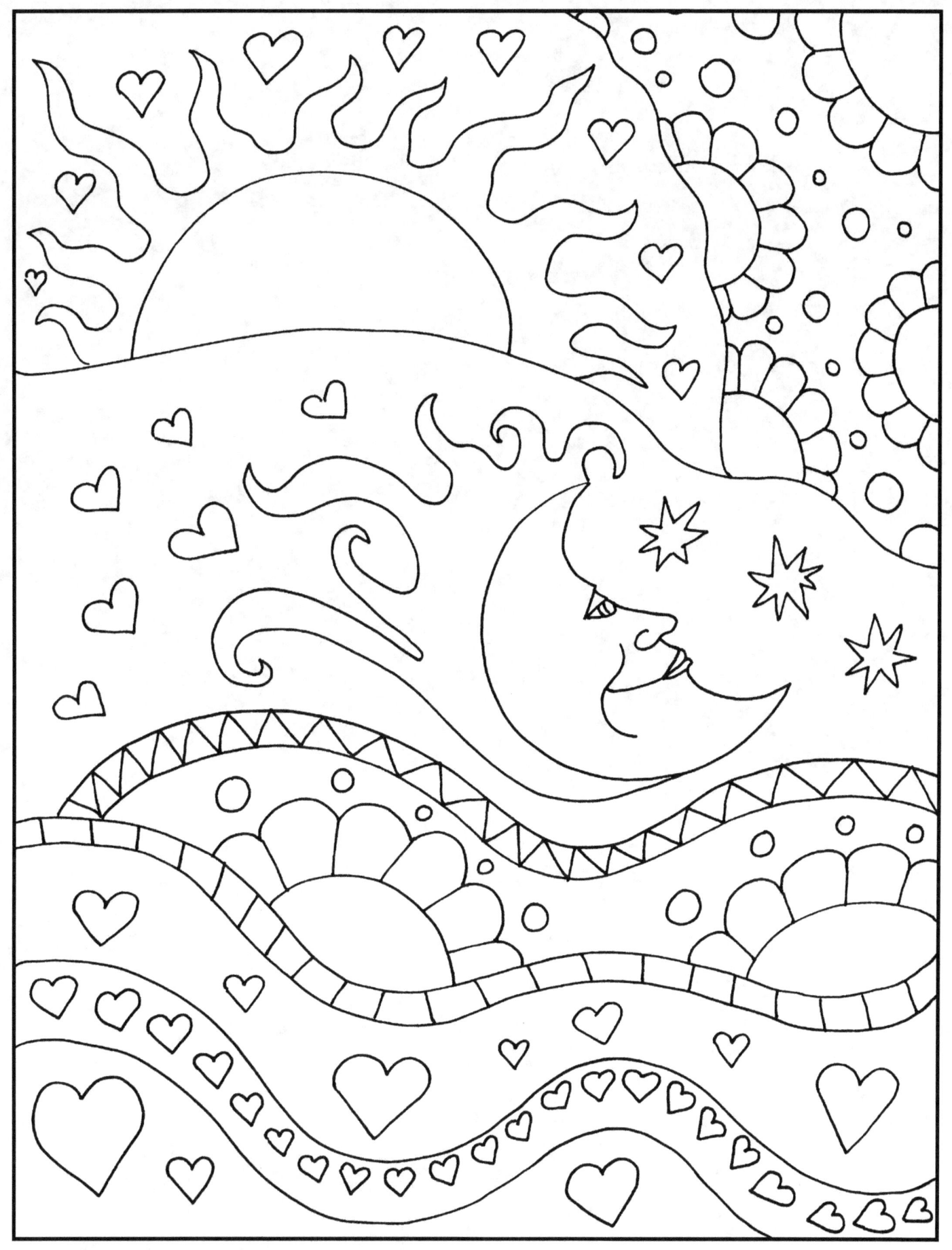

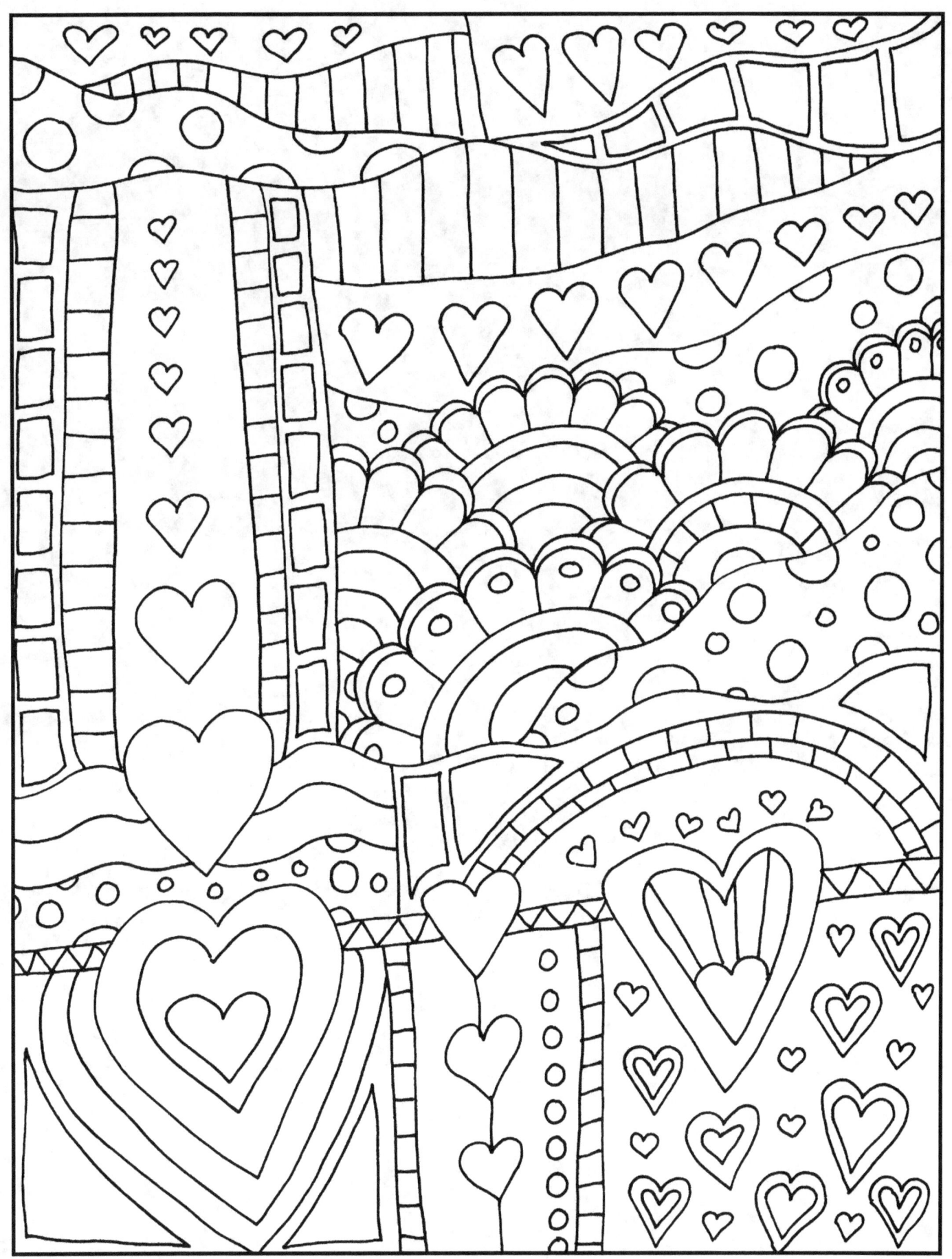

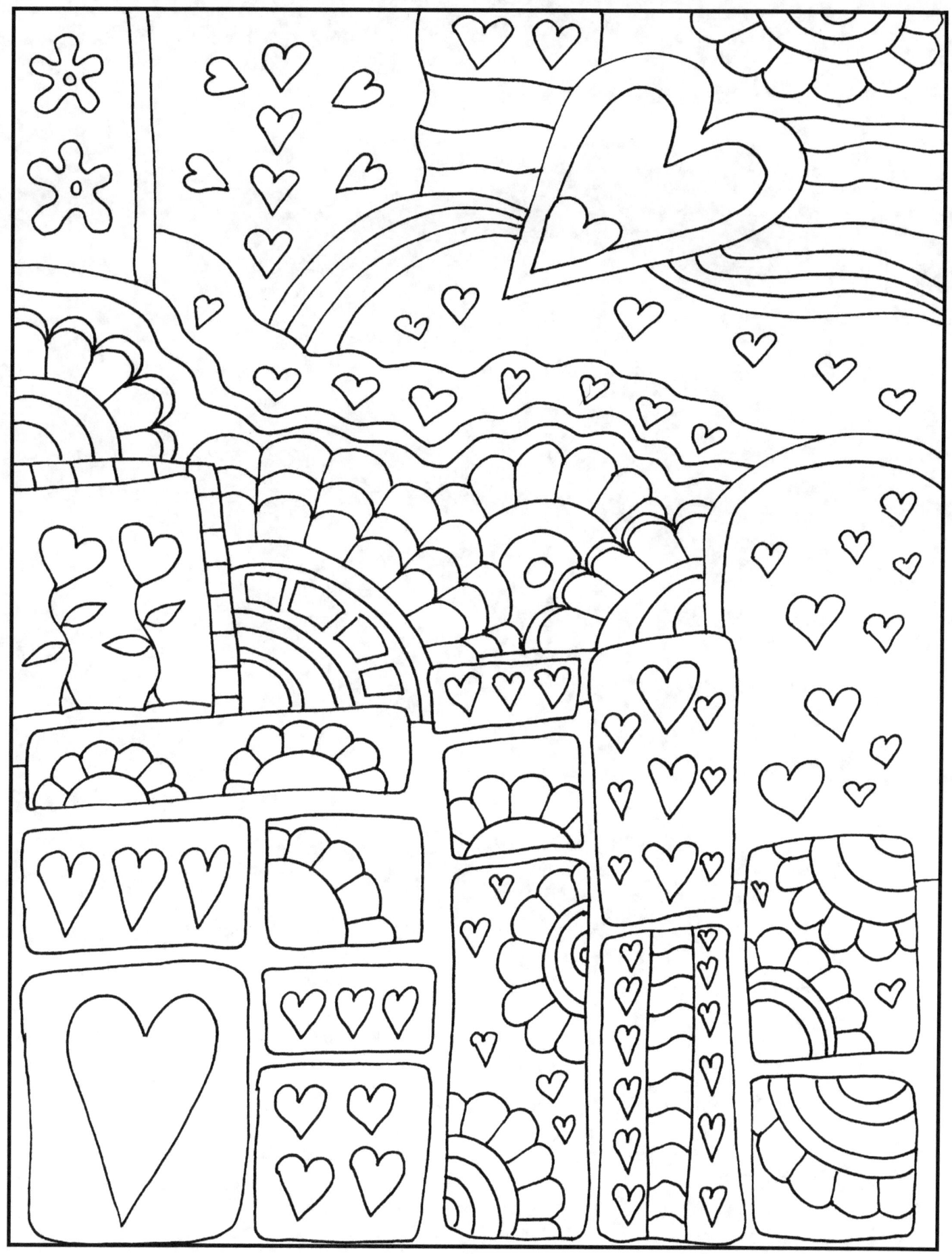

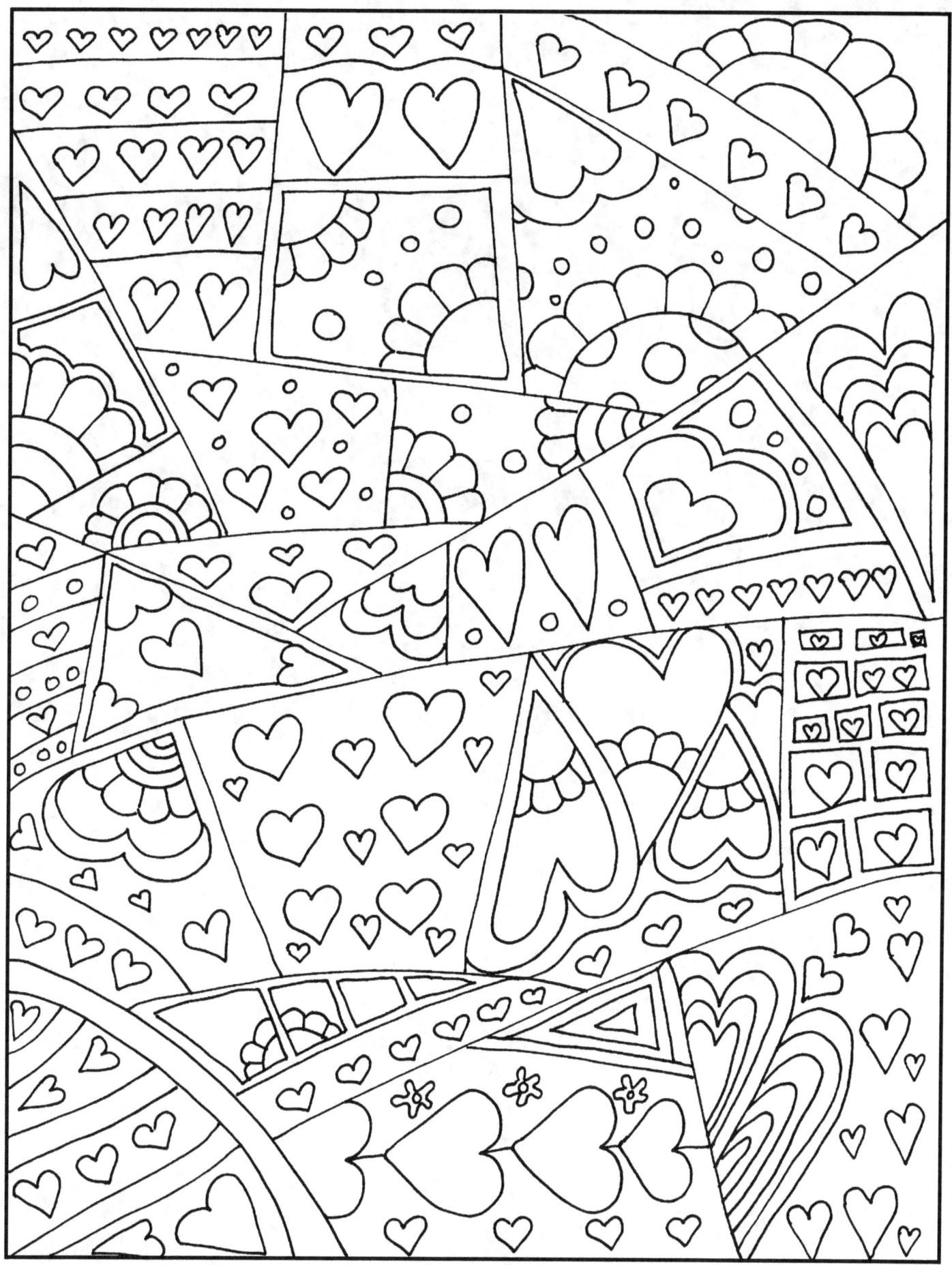

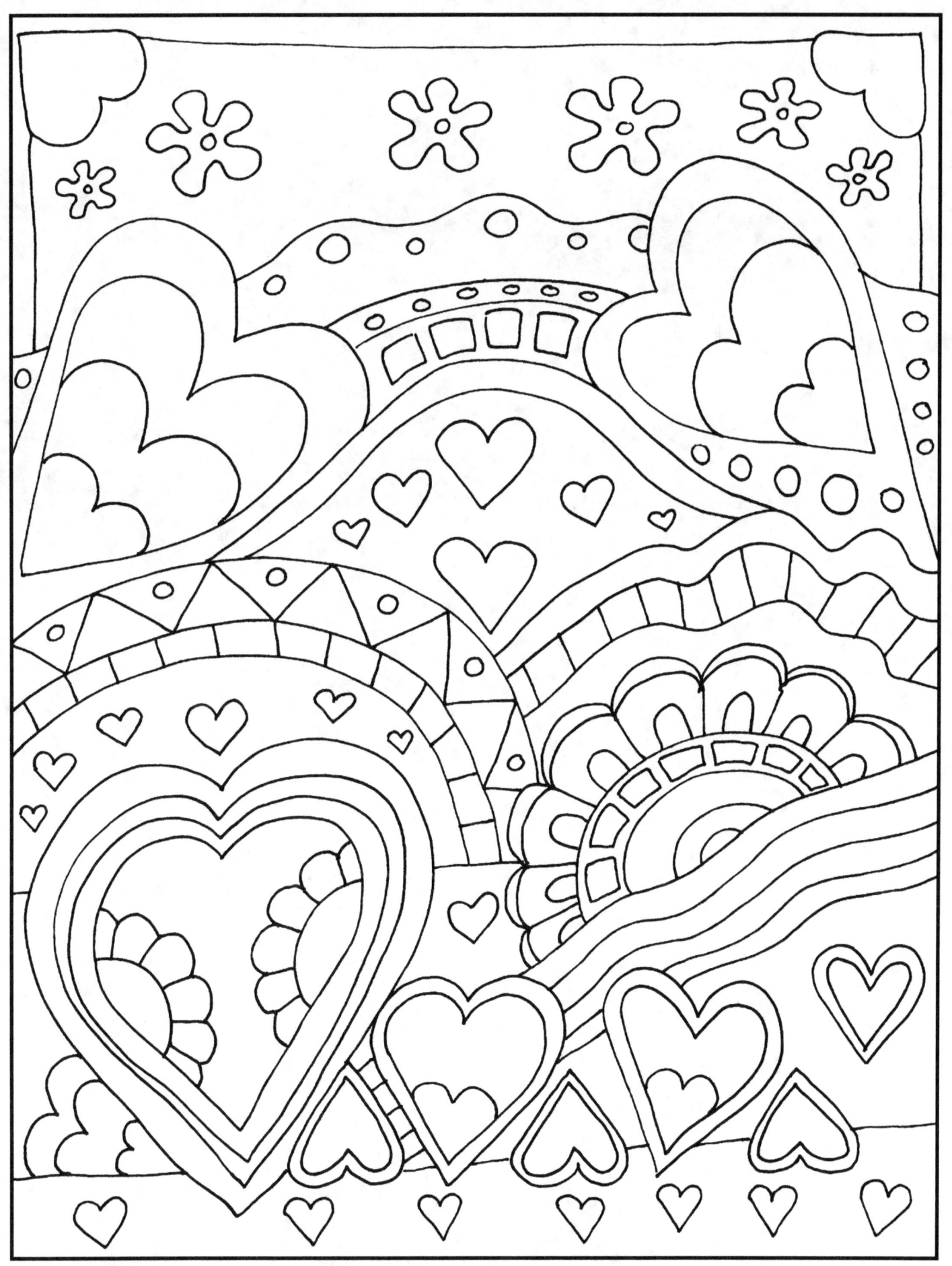

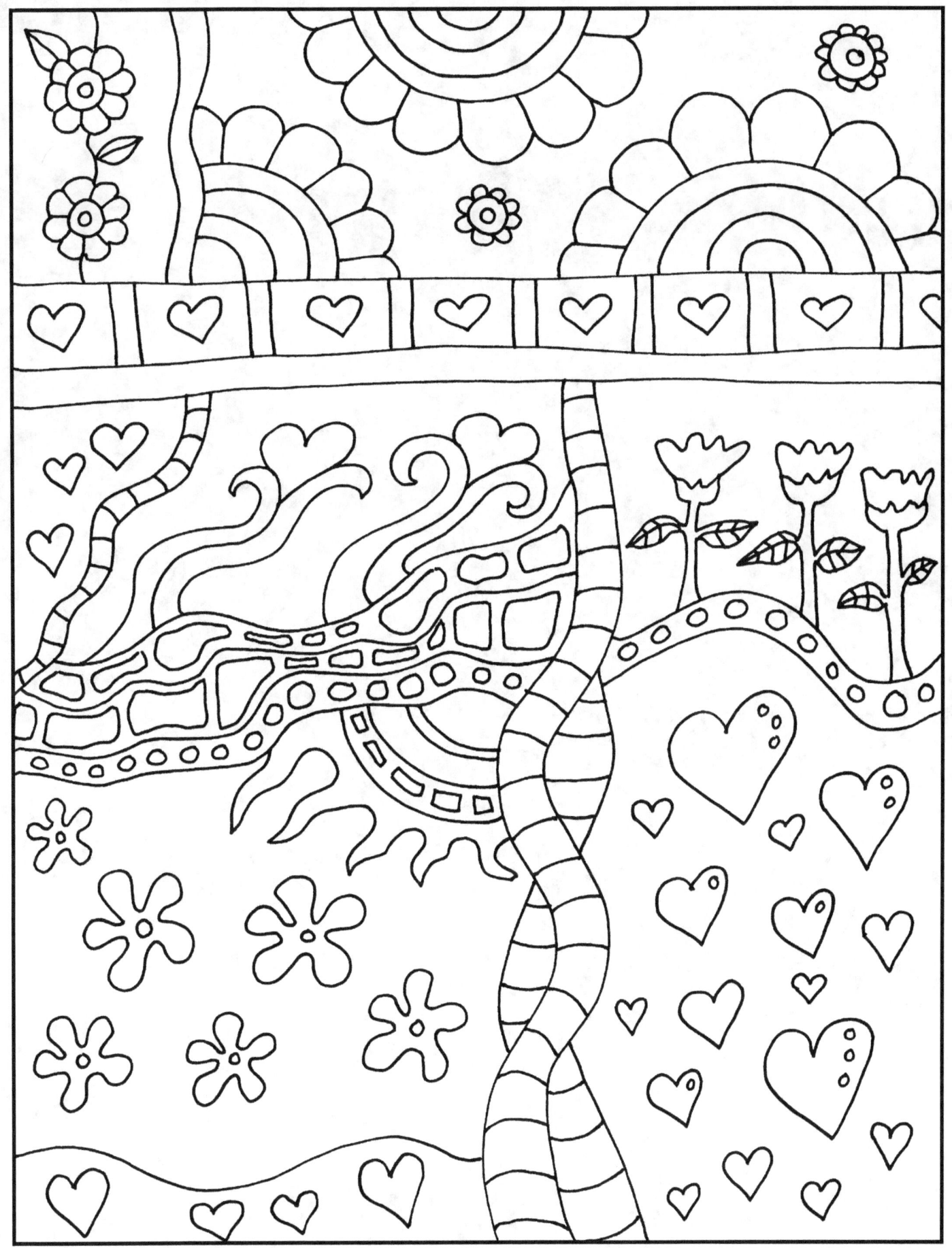

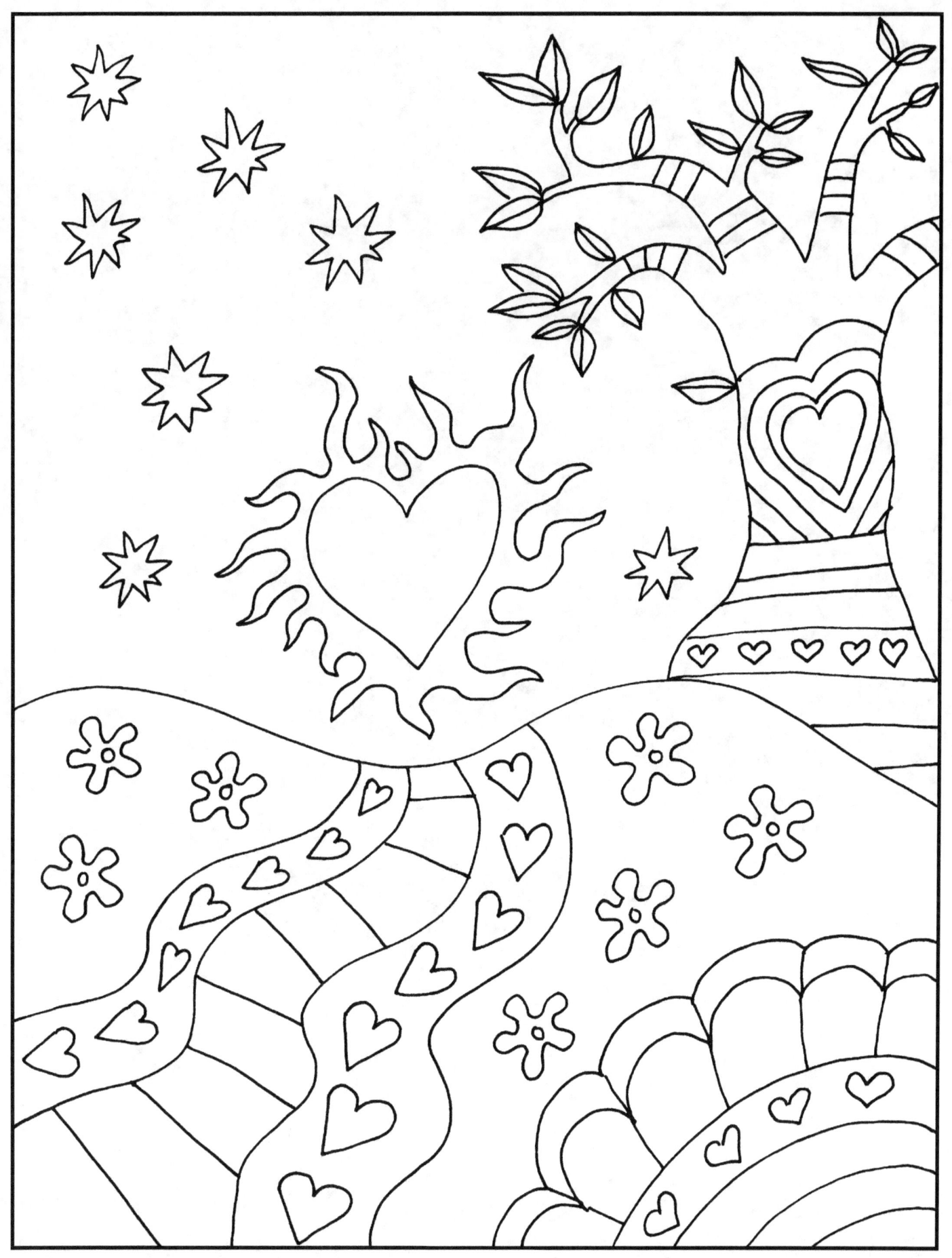

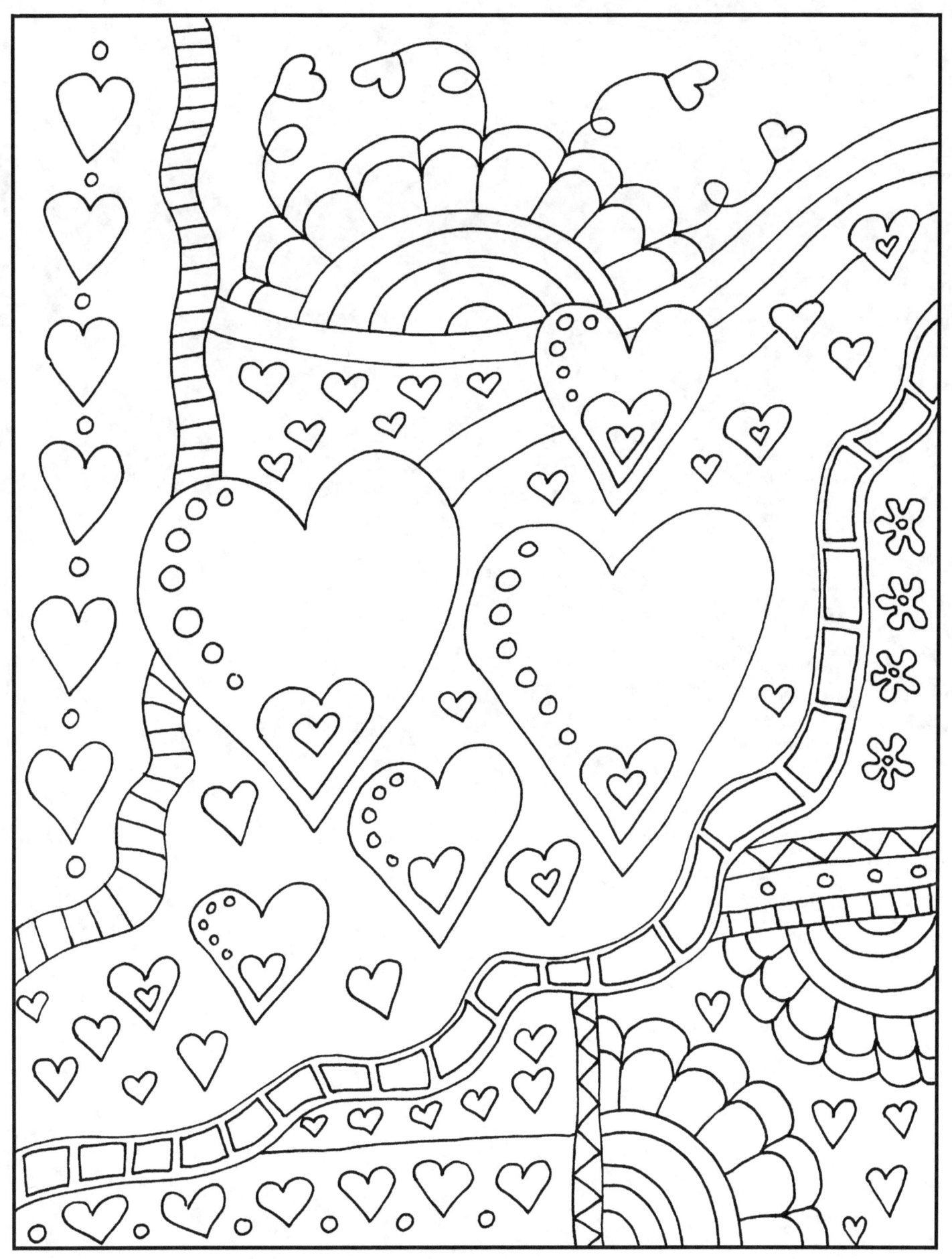

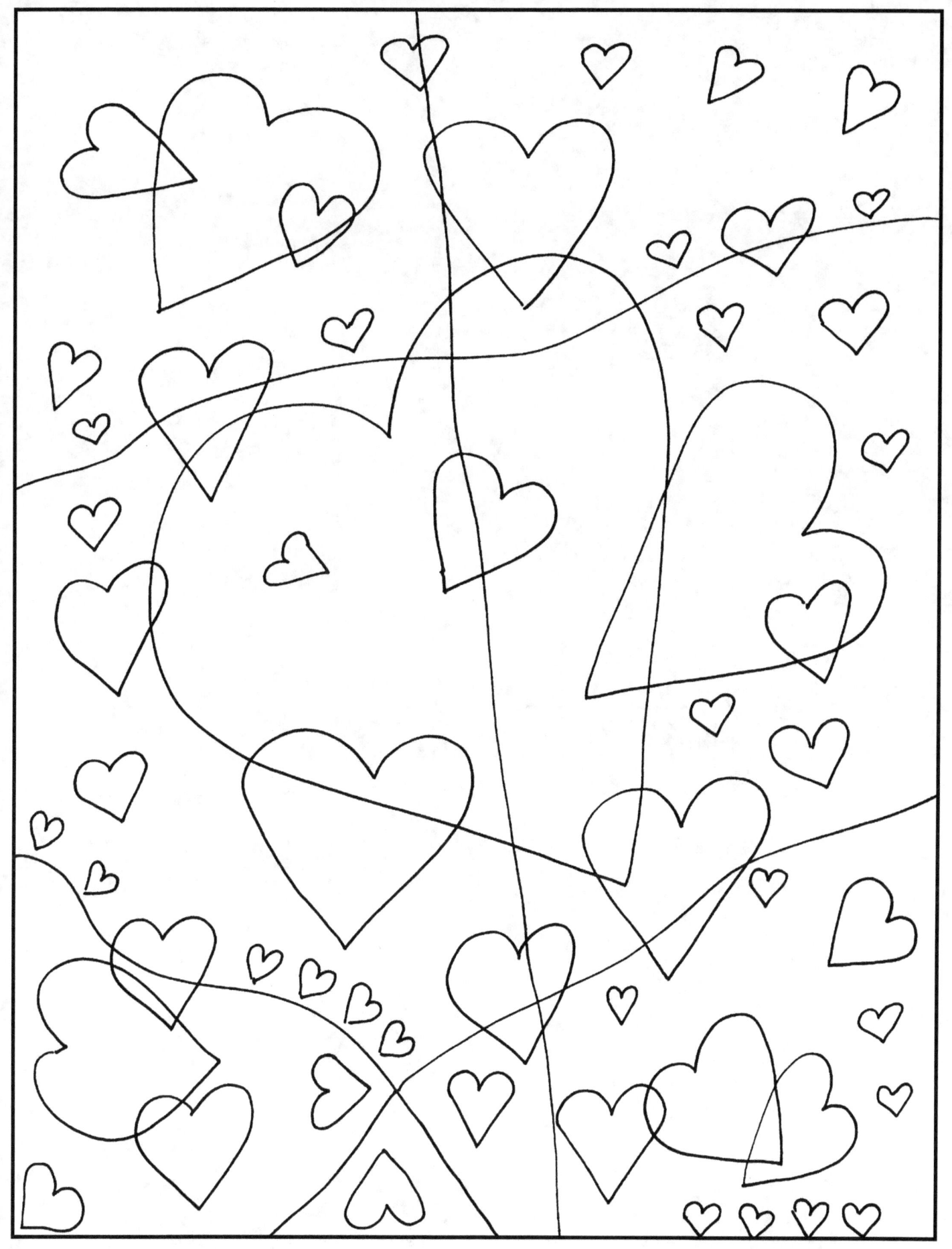

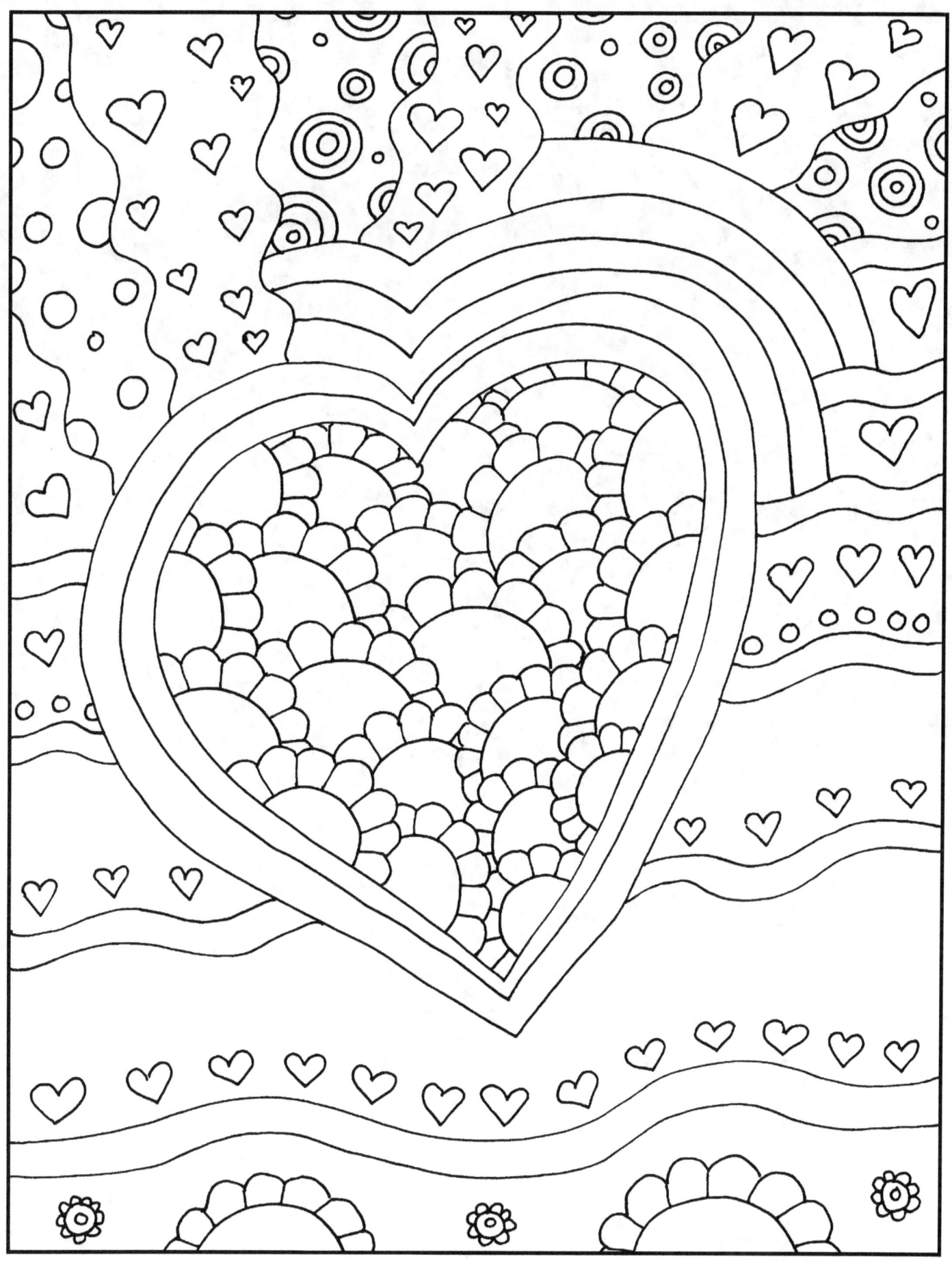

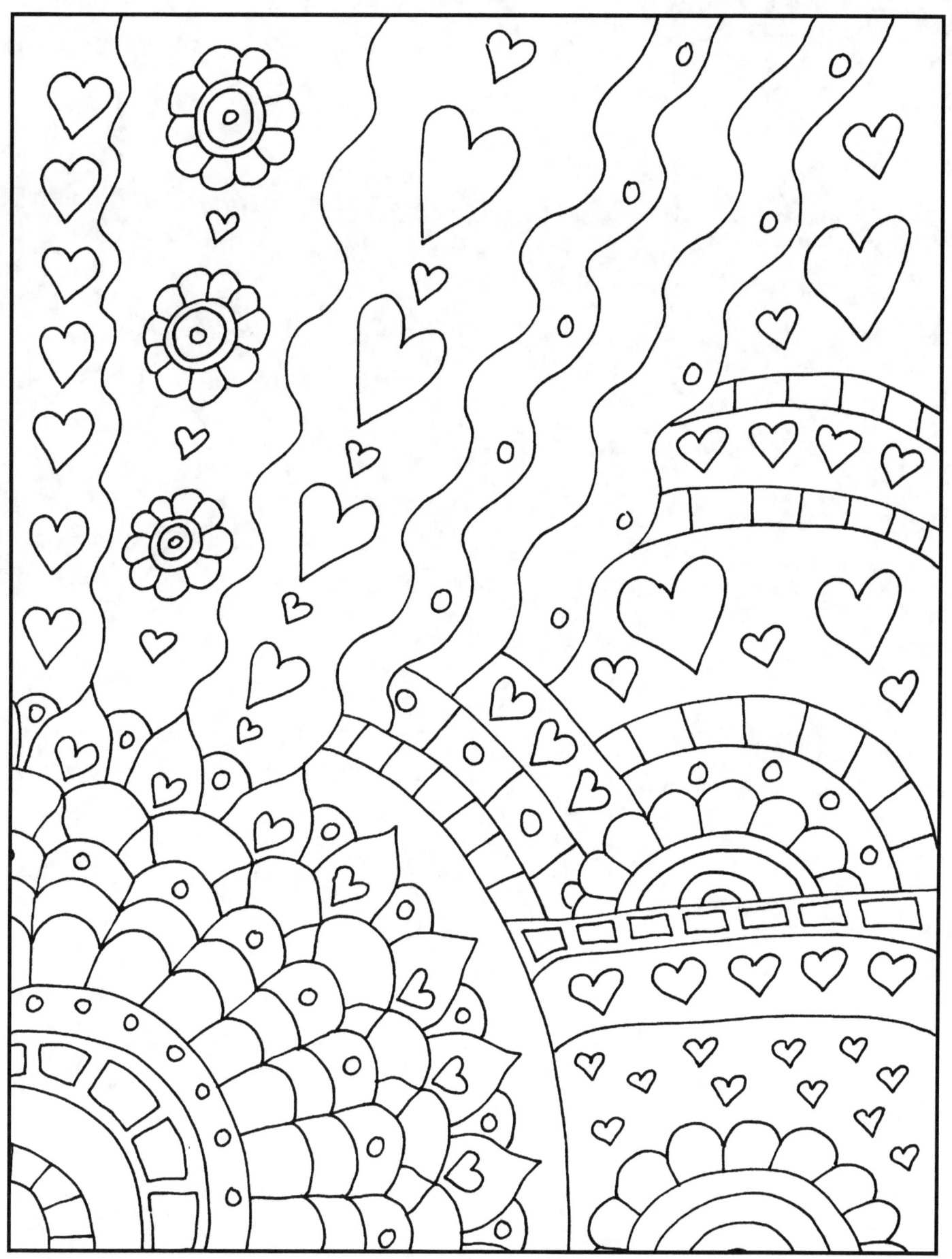

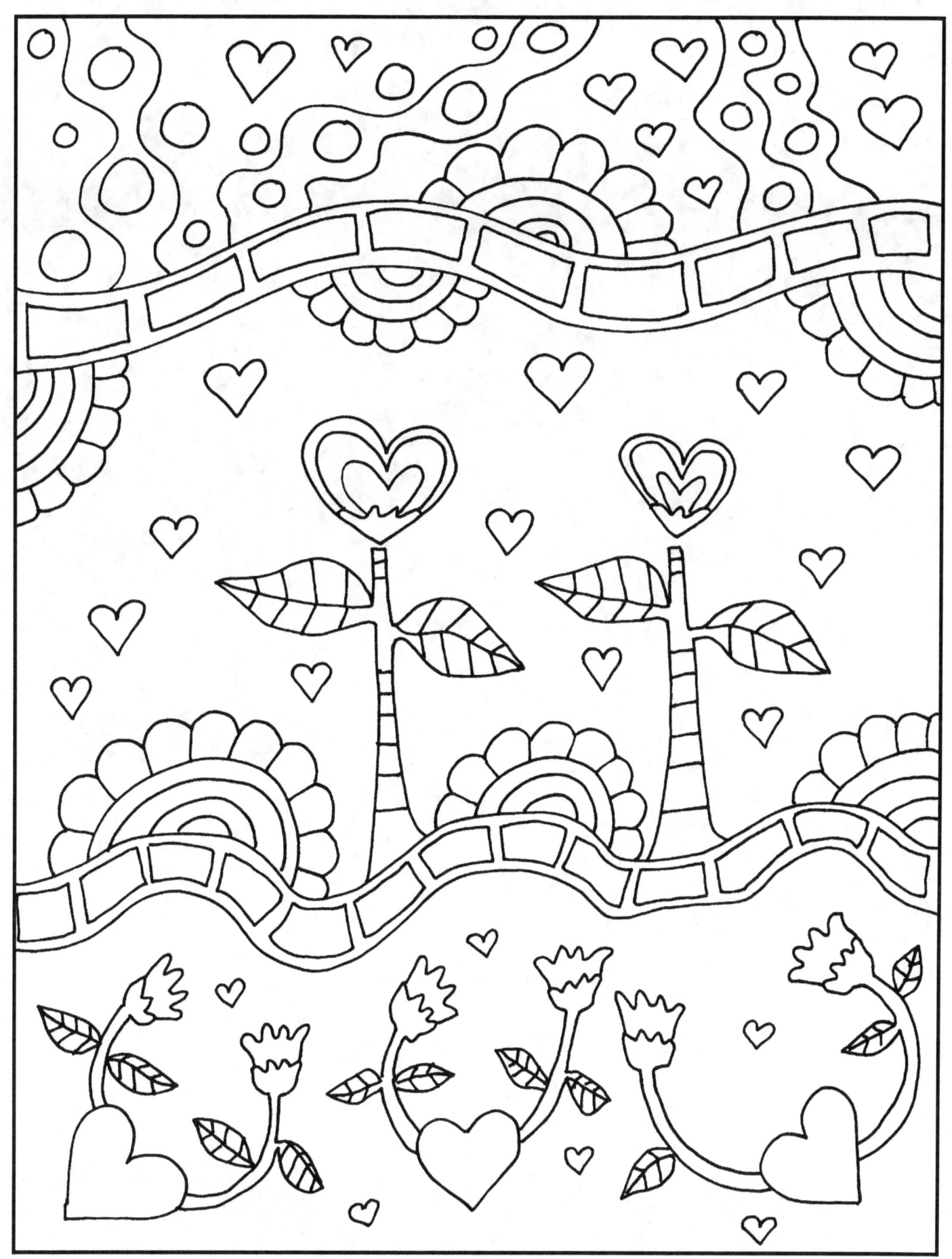

Also Available by Kimberly Garvey

- **Strange Designs** - An adult coloring book for everyone.
- **Strange Little Designs** - A mini/travel adult coloring book.
- **Simple Designs** - An adult coloring book with easier pages.
- **Simple Designs II** - Another adult coloring book with easier pages.
- **Magical Daydreams** - An adult coloring book for everyone.
- **It's Complicated** - A challenging. more detailed book for the daring colorists.
- **The Fox Book** - A foxy coloring book for everyone.
- **SUPER Simple Designs** - SUPER easy adult coloring
- **Playful Adventures** - An adult coloring book for everyone.

KIMBERLYGARVEY.COM

KIMBERLYGARVEY.COM

PROTECTION SHEET

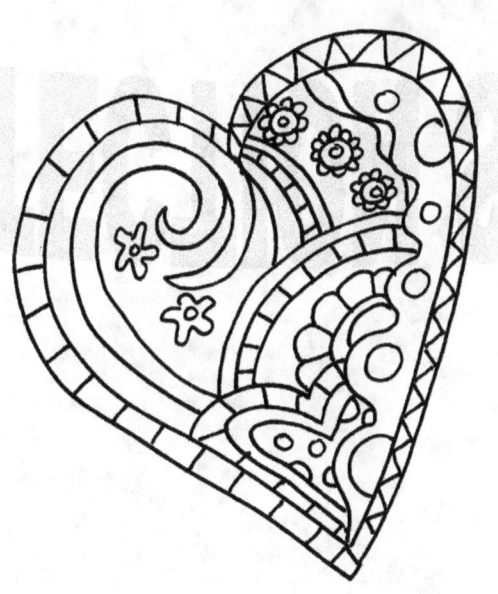

Place this page between coloring pages when using markers to prevent bleed-through.

KIMBERLYGARVEY.COM

KIMBERLYGARVEY.COM

www.ingramcontent.com/pod-product-compliance
Lightning Source LLC
Chambersburg PA
CBHW081211180526
45170CB00006B/2299